D0552619

WOTTON-UNDER-EDGE
THROUGH TIME
John Christopher

AMBERLEY PUBLISHING

First published 2011

Amberley Publishing
The Hill, Stroud
Gloucestershire, GL5 4EP

www.amberley-books.com

Copyright © John Christopher, 2011

The right of John Christopher to be identified as the
Author of this work has been asserted in accordance
with the Copyrights, Designs and Patents Act 1988.

ISBN 978 1 84868 964 0

British Library Cataloguing in Publication Data.
A catalogue record for this book is available from
the British Library.

Typeset in 9.5pt on 12pt Celeste.
Typesetting by Amberley Publishing.
Printed in the UK.

Introduction

Wotton-under-Edge is a town shaped by its location. Standing at the foot of the Cotswold escarpment, it shelters in the valleys and coombes carved into the once-wooded hills that gave it its name. These steep hills meant that Wotton was not situated on any major routes, but what they did provide were the brooks and streams that drove the great woollen mills of the eighteenth and nineteenth centuries. Evidence of the weaving and cloth-making industry can be found throughout the town in the old mill buildings and in street names such as Dyer's Brook or Water Lane.

The earliest reference to Wotton, from the Saxon Royal Charter of King Edmund of Wessex in 940, calls it Wudetun, and by the time of the Domesday Book in 1086, it had become Vutune, a dependency of the royal manor of Berkeley. Most significantly, the town was granted borough status in 1253, and this gave the inhabitants the freedom to earn their living independently of Berkeley, through commerce and industry. The original settlement was clustered around the Parish Church of St Mary the Virgin, and the oldest house in Wotton, the Ram Inn in Potters Pond, is known to have been in existence in 1350. Several accounts suggest that the old town was destroyed by fire during the reign of King John, although there doesn't appear to be any hard evidence to support this. What we do know is that, in 1252, Jone de Somers, the widow of Thomas de Berkeley, laid out a grid pattern of new streets slightly to the south of Old Town. The main street, Long Street, is on a slope running from east to west with four cross streets, Clarence Street, Orchard Street, Rope Walk and Market Street, leading to the open market area known as The Chipping.

But that's enough of the ancient history. *Wotton-under-Edge Through Time* is more concerned with the ongoing changes that have occurred in the daily lives of ordinary people, both the big ones brought about by historical events and shifts in working and living patterns, and the incidental changes that so easily pass unnoticed. It is a snapshot – a double-exposure if you like – spanning a period of around 150 years, from the earliest days of photography up to the present day. Most of the older images date from 1900 onwards and many will fall within the living memories of the town's older residents.

Not surprisingly, Wotton has seen much change over this period, which encompasses enormous shifts in work patterns, as a result of the industrial revolution of the nineteenth century, and a transformation in the way we all get about. The two are inexorably linked, but it

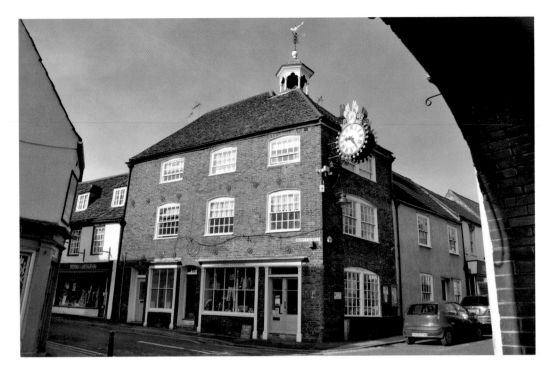

Above: The brick façade of the Tolsey House conceals a sixteenth-century building that was given to the town by the Countess of Warwick in 1595. It is capped with a bell turret and dragon weathervane, and the town's famous clock commemorates Queen Victoria's Diamond Jubilee of 1887.

Below: Berkeley House in Long Street is a reminder of Wotton's close associations with Berkeley. (JC)

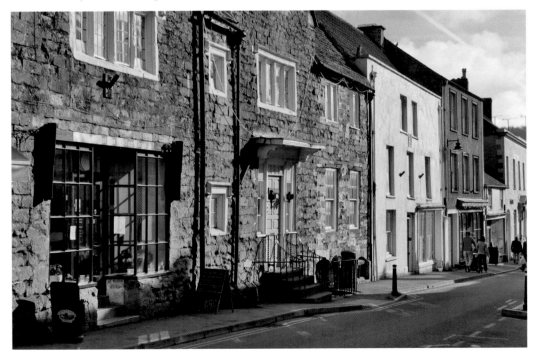

is perhaps the latter that has had the most obvious impact upon Wotton and hundreds of other country towns the length and breadth of Great Britain. You only have to compare the old and new images to see that once-empty streets are now cluttered with parked cars, and to replicate some of the original camera positions means taking your life into your hands on the busier roads. And in many cases there are new buildings where the original photographer once stood, or new trees have grown to obstruct the view.

Some of the changes are more gradual. In Victorian times Wotton was brimming with small shops, not just running the length of Long Street and High Street, but spilling out in every direction into Bradley Street, Market Street, Church Street and beyond. Before the advent of the motor car, people had to buy what they needed in the town, from clothing and provisions to tools or pots and pans, and the evidence of these former shops is still to be found in a large number of premises which have become private residences over the years. Thankfully, many of these family-run businesses have survived, albeit confined within the centre of the town. The unbroken frontages of the older streets have retained their character with an eclectic mixture of architectural styles and building materials ranging from stone to locally produced redbrick.

Unfortunately, this individuality does not extend to the newer housing estates. Wotton's population currently stands at around 5,500; about the same as at its peak at the height of the weaving and cloth-making industry's days. The big difference has come with the demise of extended families living within a single dwelling and, consequently, new housing estates have spread outwards into the surrounding farmland: Dryleaze and Parklands in the 1960s and 1970s, followed by Shepherds Leaze, Cherry Orchard and Bearlands. Working patterns have also changed. Several of the old woollen mills have found new life for a variety of businesses, most notably New Mills, which is now the headquarters of Renishaw plc, the biggest employer in the area.

Wotton will continue to evolve with the times and further change is inevitable. A hundred years from now, they may use the 2011 photographs from this book to create a twenty-second-century edition of *Through Time*. If they still have books that is.

How to use this book

The main part of *Wotton-under-Edge Through Time* has been arranged in the form of a tour around and through the town, and it can be used as a guide book. The route, easily achieved on foot, begins on the eastern side approaching via the Wortley Road, passes along School Road to take in the Parish Church on Culverhay and the almshouses at the foot of Parklands, then returns past the War Memorial up Old Town to the Tabernacle, along Bear Street and Haw Street, returning down the High Street into Long Street, with excursions into the side streets to include the Town Hall and the Chipping.

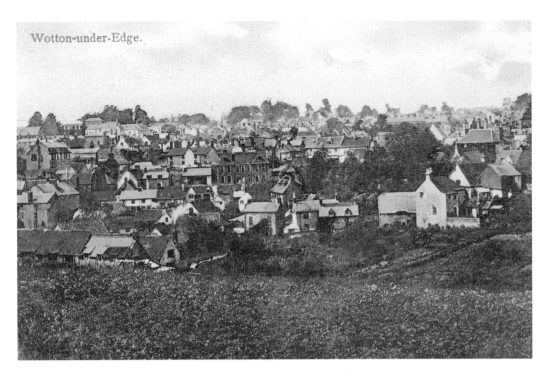

Wotton-under-Edge.

Wotton-under-Edge

A view of Wotton with a maze of roofs seen across Potters Pond from what is now the Court Orchard estate. The Grammar School is in the centre, and Ludgate Hill runs from the bottom left up to Long Street. The Tabernacle is visible in the top-right corner of the modern photograph. (JC)

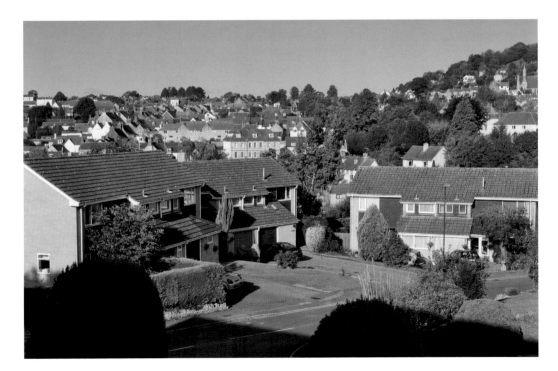

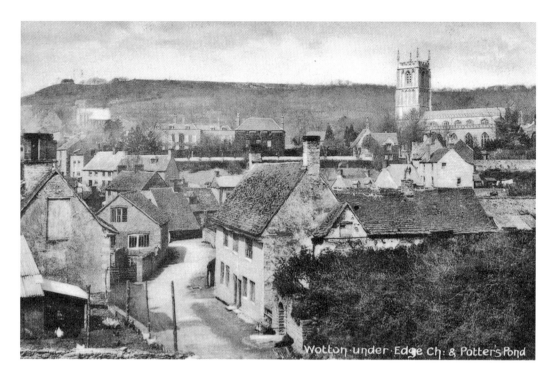

Synwell Lane and Potters Pond

The gable end of Moore House is on the left, and Wotton Hill can be seen top left. This is one case where it is impossible to recreate the exact camera position of the older image because of new buildings, but it is the increase in trees both in the town and on the hill that is the most noticeable. (JC)

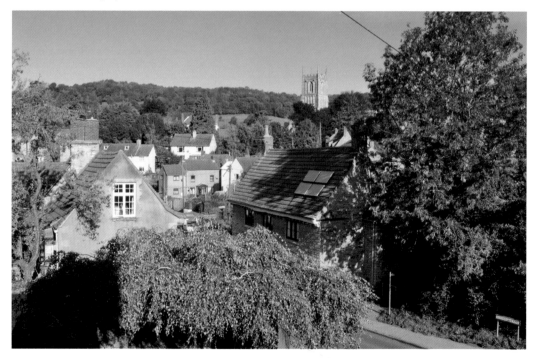

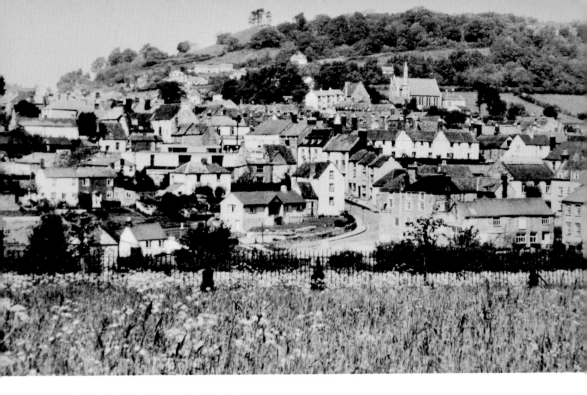

Across Dyer's Brook and Wortley Road
Two views of central Wotton from the cemetery – one taken in 1968 and the other in 2011. At first sight, they don't appear all that different, but the tall tree in the new photograph obscures the sprawl of Parklands to the right of the Tabernacle. (WHS/JC)

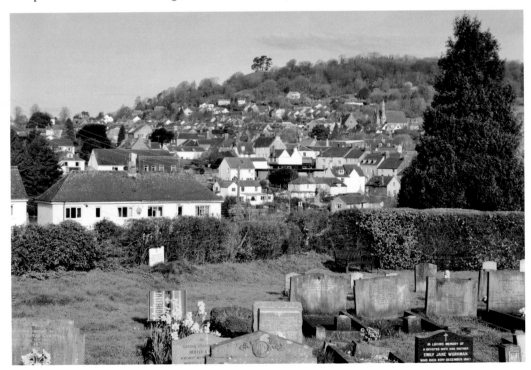

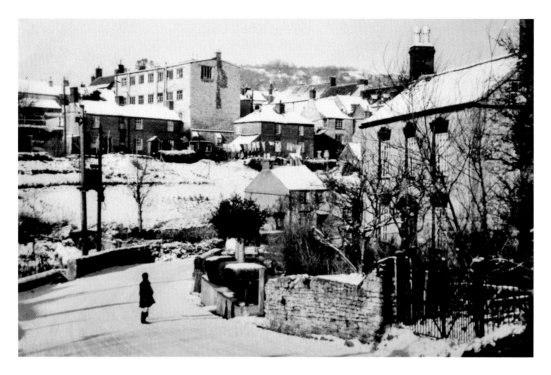

Mitre Pitch and Steep Mill
A wintry scene at the bottom of Mitre Pitch in 1947, although modern maps now show this stretch of road as Dyer's Brook. The tall building on the hill is the old Steep Mill, which was used variously by Sir Isaac Pitman and also by the Grammar School at one time. The County Library building now stands on the site. (WHS/JC)

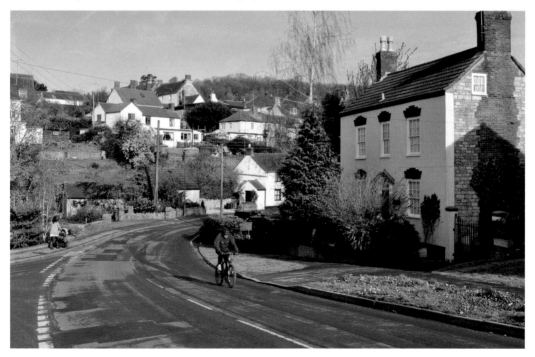

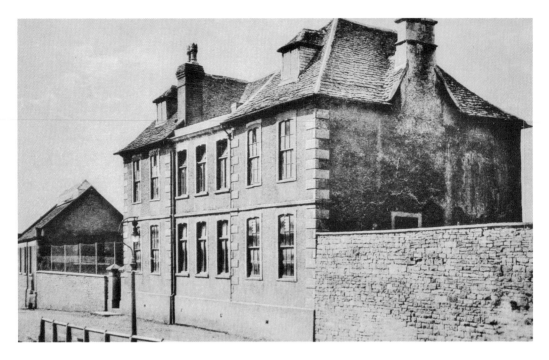

Katharine Lady Berkeley Grammar School

The Grammar School, built in 1726, is shown after the 1900 alterations to the façade which saw the recessed central section, with the main entrance, brought forward flush with the rest of the building. Since then the roof has also been brought forward, the stonework has been exposed, the chimneys have gone and the school buildings have become private residences known as Katharine Lady Berkeley Mews. (WHS/JC)

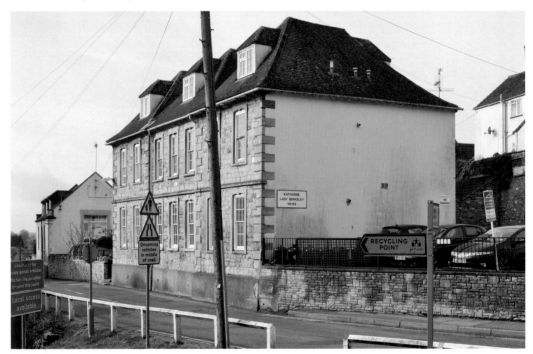

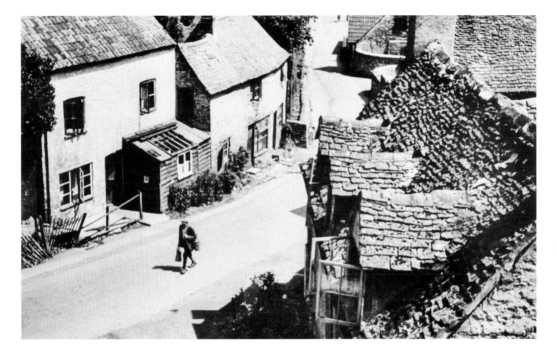

Potters Pond

There are parts of Wotton that hardly seem to have changed at all. The old view looking down upon the Potters Pond road was taken from one of the windows of the old Grammar School. The new view is from just beside it. The pond has gone, but Ram Inn, said to be Wotton's oldest house, is just behind the gables of the right-hand building. (WHS/JC)

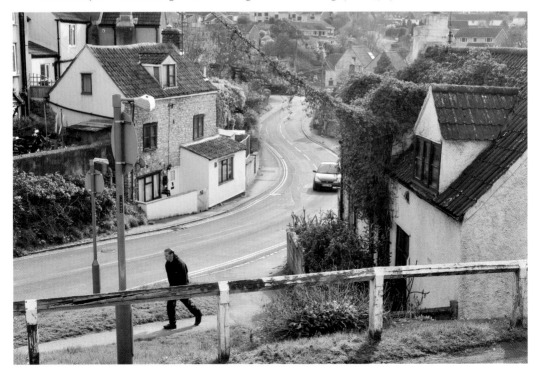

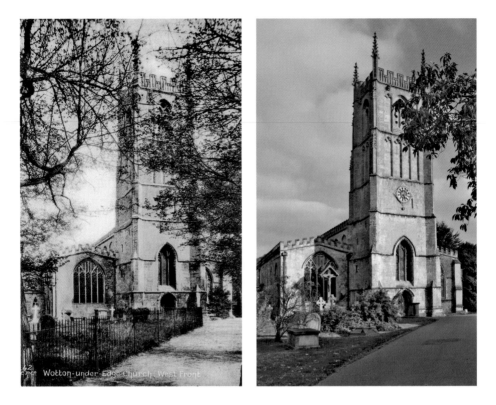

Wotton-under-Edge Church: West Front

St Mary the Virgin

A major landmark in the town, the warm Cotswold stone tower of the parish church of
St Mary dates back to the fourteenth century and houses a peal of eight bells. The interior
of the church is very spacious, the aisles are wide and the plain white walls are adorned
with memorials to former Wotonians. Note the variations in the decorative treatment on
the main columns. (JC)

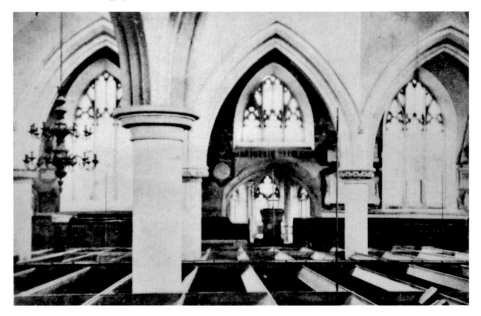

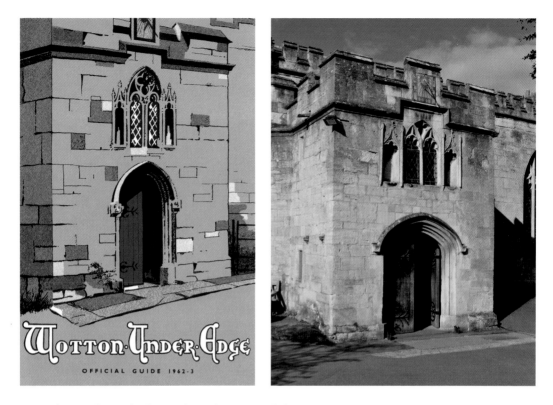

The south porch, featured on the cover of this 1962–63 town guide, has a priest's chamber above the thirteenth-century doorway, and above that is a sundial. The interior view across the nave shows the entrance to the Katharine Chapel, a small five-sided chapel which was probably named after Katharine Lady Berkeley or, possibly, St Catherine of Alexandria, the patron saint of weaving. (JC)

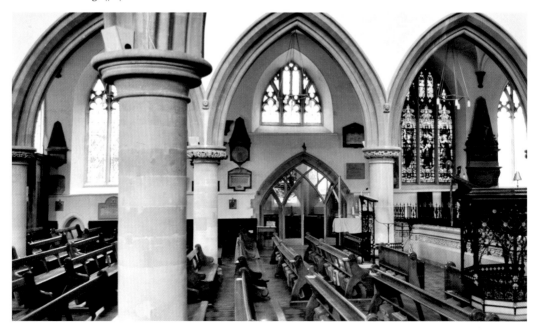

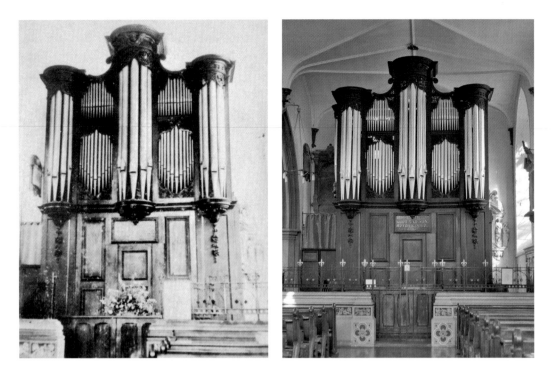

Handel's organ

This grand organ was originally built by Kit Schreider for King George I in 1726, for St Martin-in-the-Fields in London. Handel is said to have played it there several times, although not in Wotton sadly, where it came when St Martins acquired a new one in 1799. Initially located in the gallery at the back of the church, it was moved to its current position in the south aisle during renovations in 1882. (JC)

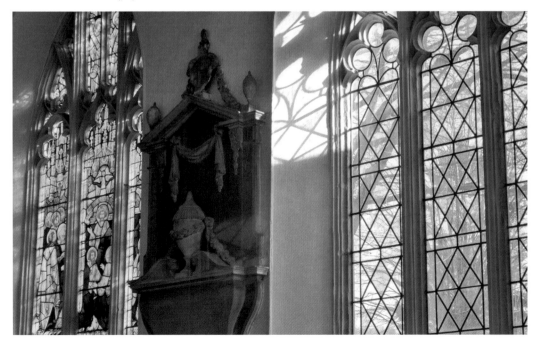

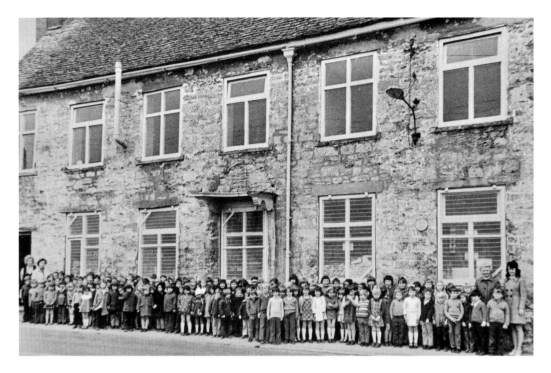

Blue Coat School, Culverhay

The old Blue Coat School stands opposite the entrance to St Mary's church. The school itself was founded in 1693 and this building dates from 1715. In 1974, Blue Coat moved into the old Secondary Modern huts, off the Chipping, and combined with the National School in 2000 as the Blue Coat C of E Primary School at the new Symn Lane site. (WHS/JC)

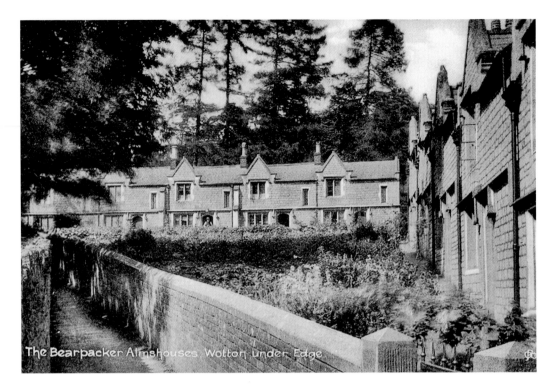

The Bearpacker Almshouses, Wotton under Edge

Bearpacker's Almshouses, Culverhay

Just up from the church, and across from the old Blue Coat School at the foot of Parklands, are the Bearpacker's Almshouses – one of three groups of almshouses in the town. These were endowed by Miss Ann Bearpacker in 1837 to provide accommodation for five men and five women of the parish. They are arranged in two groups of five, separated by a gap. (JC)

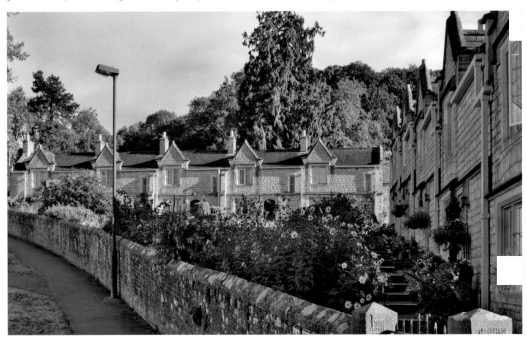

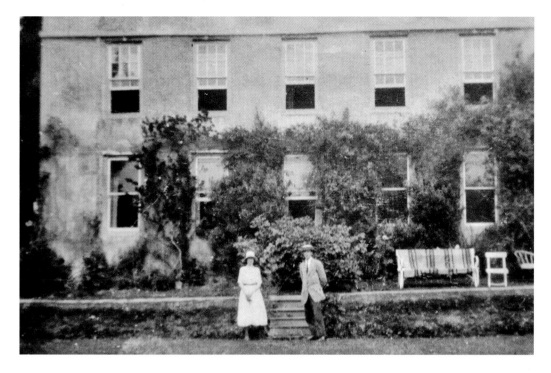

Under the Hill House, Adey's Lane
Overlooking the almshouses, Under the Hill House was the home of the Bearpacker family and later the Adeys, who were clothiers and landowners. The house was extended and restyled in the early eighteenth century, when a third storey was added. You can see the change in style on the windows and glazing. Adey's Lane leads up to the Old London Road. (WHS/JC)

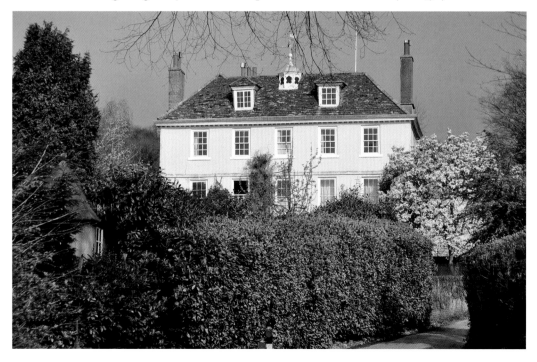

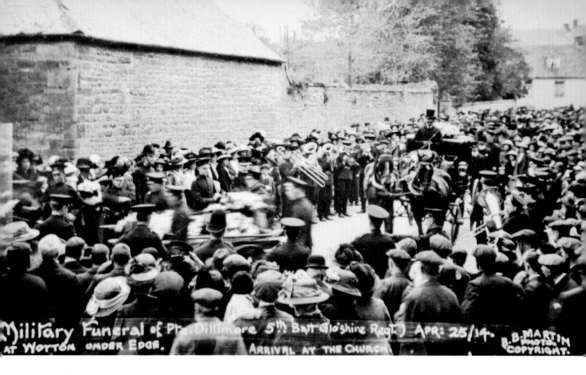

Military Funeral of Pte Dillimore 5ᵗʰ Batt Glo'shire Regt.) APR: 25/14.
AT WOTTON UNDER EDGE. ARRIVAL AT THE CHURCH. B.B.MARTIN PHOTO COPYRIGHT.

A military funeral
A large crowd has turned out to pay their respects to Private Dillimore, of the 5th Battalion of the Gloucestershire Regiment, as the funeral party arrives at the gates of the church. Dillimore died of natural causes, and as the photograph is dated 25 April 1914, four months before the start of the First World War, his name does not appear on the war memorial. The gateway to the Old Rectory House is in the background, with the new Culverhay Surgery on the left. (WHS/JC)

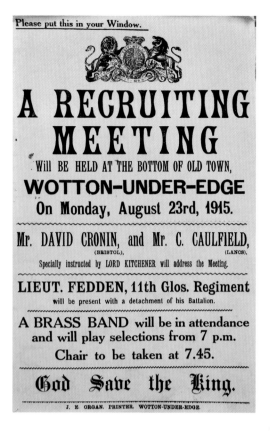

A RECRUITING MEETING

Will BE HELD AT THE BOTTOM OF OLD TOWN,

WOTTON-UNDER-EDGE

On Monday, August 23rd, 1915.

Mr. DAVID CRONIN, and Mr. C. CAULFIELD,
(BRISTOL), (LANCS),

Specially instructed by LORD KITCHENER will address the Meeting.

LIEUT. FEDDEN, 11th Glos. Regiment
will be present with a detachment of his Battalion.

A BRASS BAND will be in attendance
and will play selections from 7 p.m.

Chair to be taken at 7.45.

God Save the King.

J. E. ORGAN, PRINTER, WOTTON-UNDER-EDGE.

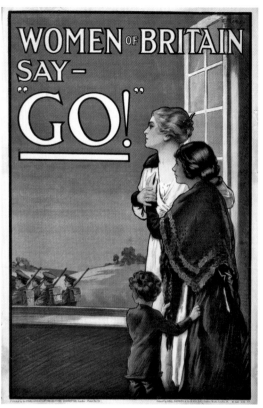

WOMEN OF BRITAIN SAY — "GO!"

The First World War

Like many towns, Wotton lost its fair share of young men during the First World War. This poster announces a recruiting meeting held at the bottom of Old Town in August 1915. A year into the conflict, the machinery of war was placing an ever-increasing demand upon manpower. Propaganda posters entreated the women of Britain to say 'Go!' adding to the social pressure to enlist. The church has several graves for the fallen, including this one for two Vine brothers who died a year apart, both aged twenty-one. Private L. Vine was killed on the very last day of the war. (WHS/LoC/JC)

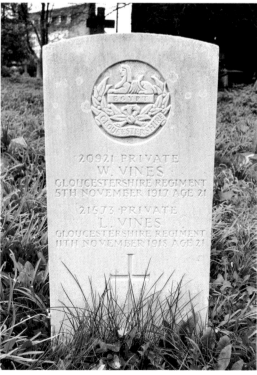

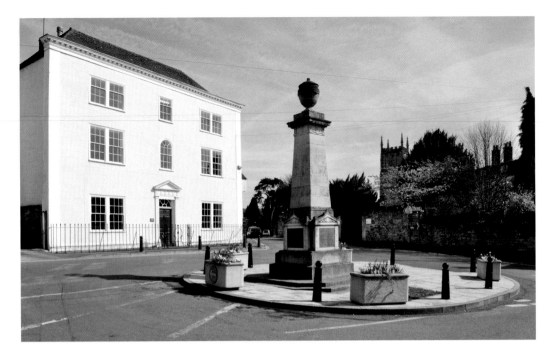

Wotton's war memorial

The town's war memorial at the bottom of Old Town was dedicated on a rainy 20 June 1920. Ruth Cornock, who lost eight sons in the war, pulled a cord to release a flag covering the memorial. The names of the fallen include many surnames that are still well known in the town. A plaque was added after the Second World War with a notably shorter list of names. On the left in the upper picture is Edbrook House. (JC)

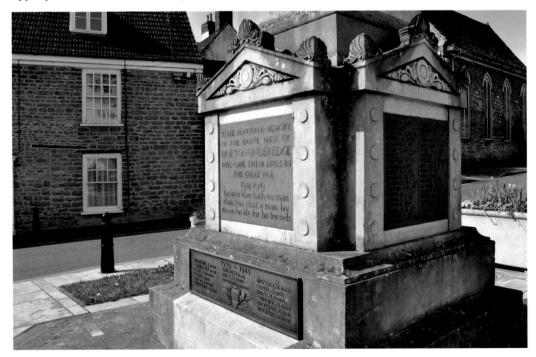

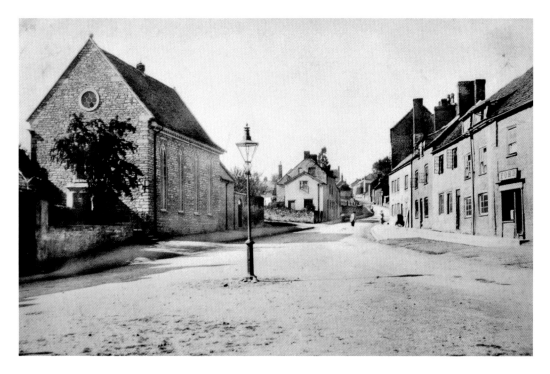

The bottom of Old Town

Looking up the hill, into Old Town, the Meeting House is on the left. Before the erection of the war memorial, after the First World War, only a solitary gas lamp marked the spot. Today, this is a busy roundabout, but as the old image shows, there wasn't any traffic to speak of a hundred years ago. The new photograph was taken during a deceptively quiet moment. (WHS/JC)

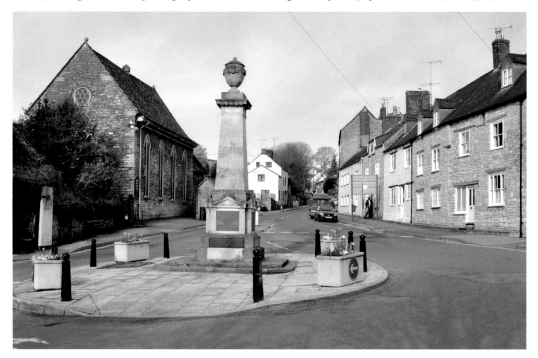

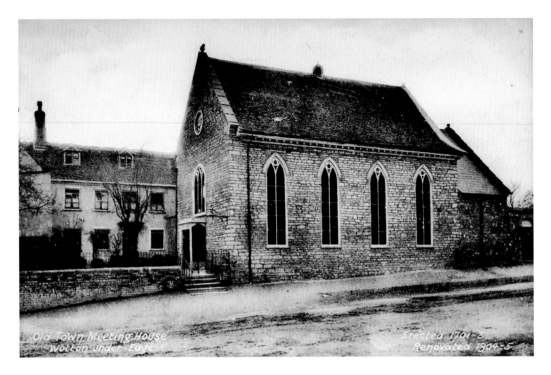

The Old Town Meeting House

Completed in 1703, the Old Town Meeting House is regarded as the first 'Free Church' in Wotton. Originally, it featured square windows, in four pairs, with one above the other, and these were replaced with the more church-like, tall, Gothic-arched windows in 1903. The Meeting House is no longer in use and is awaiting a new community role. (JC)

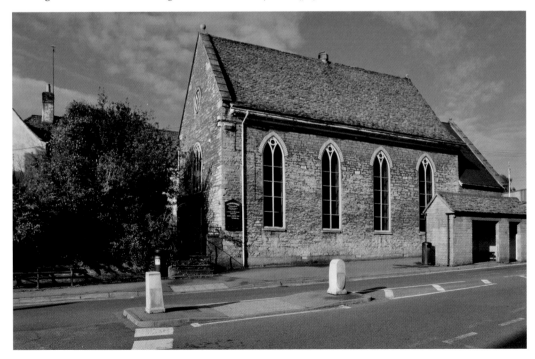

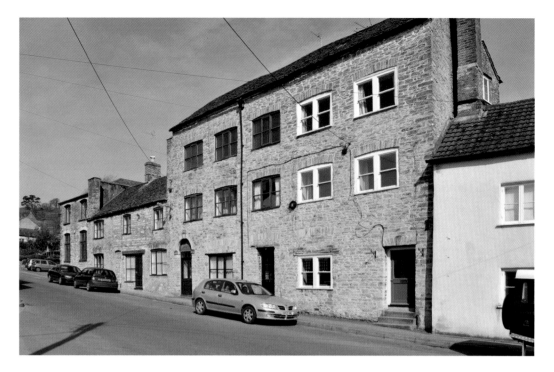

Old Town mills

There is evidence of the town's woollen industry in these former mill buildings. Old Town Mill, at the far end of this group, has been converted into the Roman Catholic Presbytery, while the other buildings are now private residences. The postcard, *below*, celebrates the compact Jacquard embroidery machine created by J. Hayward of Coventry and Wotton-under-Edge. (JC/C.McC)

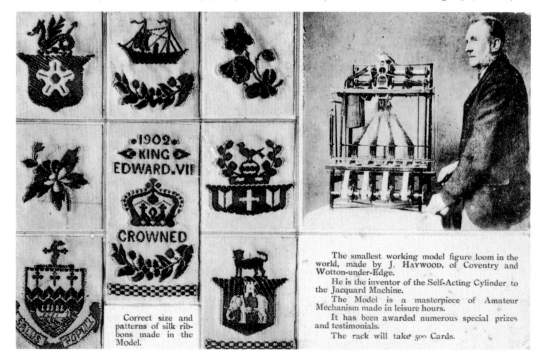

Correct size and patterns of silk ribbons made in the Model.

The smallest working model figure loom in the world, made by J. HAYWOOD, of Coventry and Wotton-under-Edge.

He is the inventor of the Self-Acting Cylinder to the Jacquard Machine.

The Model is a masterpiece of Amateur Mechanism made in leisure hours.

It has been awarded numerous special prizes and testimonials.

The rack will take 500 Cards.

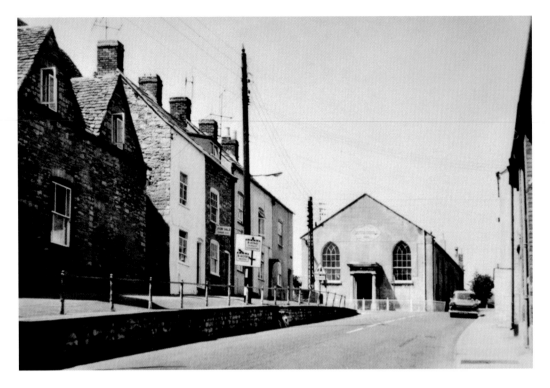

The British School, Bear Street
The former school building, founded in 1843 for non-conformist children, was located at the top of Old Town, on the corner of the junction of Bear Street. It was demolished in the 1970s, and the school moved to new premises on Wortley Road. (WHS/JC)

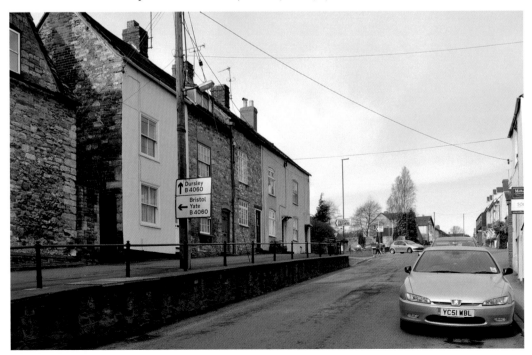

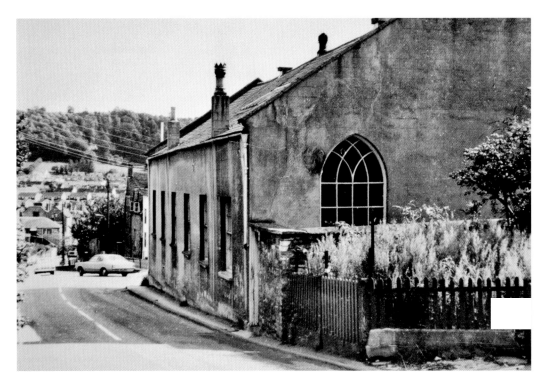

The British School building

Looking back down through Old Town, the school building has gone and the site is now part of Bear Street Garage's forecourt for used cars. Just as with some of Wotton's mill buildings, it is hard to imagine that permission to knock it down would be granted nowadays, but attitudes to conservation have changed enormously in recent decades. (WHS/JC)

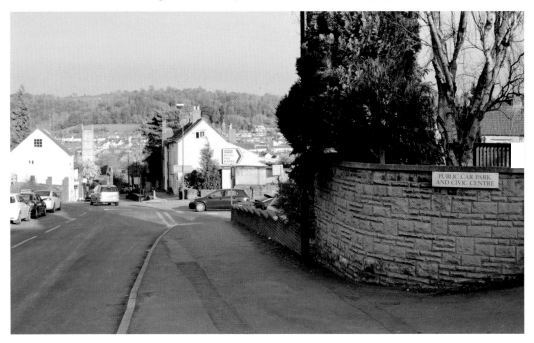

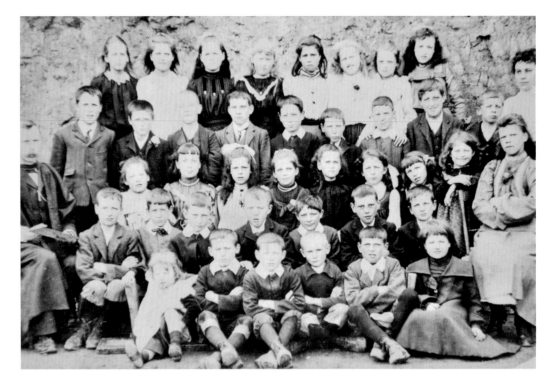

The class of 1900

The clothes and hairstyles may change, but the class photograph remains an icon of school life. This is the junior class at the British School *c.* 1900, with the headmaster, Mr Dennison, on the left and a very young assistant teacher, Miss Mabel Tandy, on the right. The main assembly hall is shown below. (WHS)

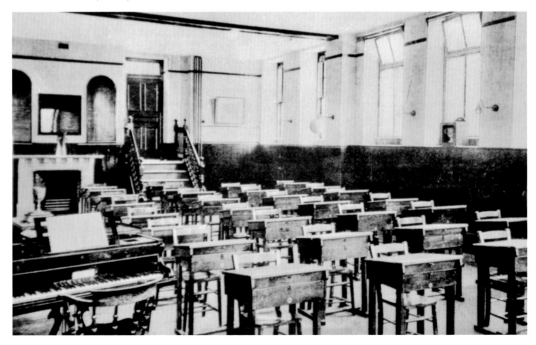

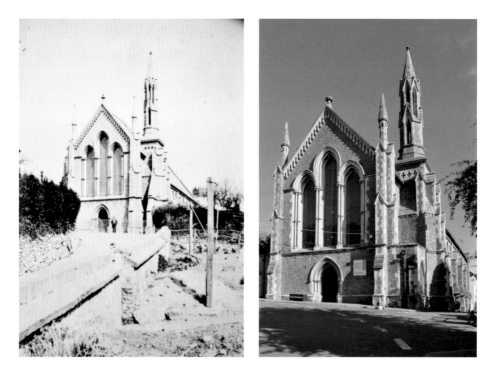

Tabernacle and almshouses

The former Tabernacle Congregational Church is in the Gothic-revival style much in favour in the 1950s. It replaced an earlier chapel built by the Reverend Rowland Hill, not to be confused with the postage stamp man, and is now used as an auction house. The original almshouses behind the church have become private residences; the newer Rowland Hill Almshouses are located on Tabernacle Pitch. (JC)

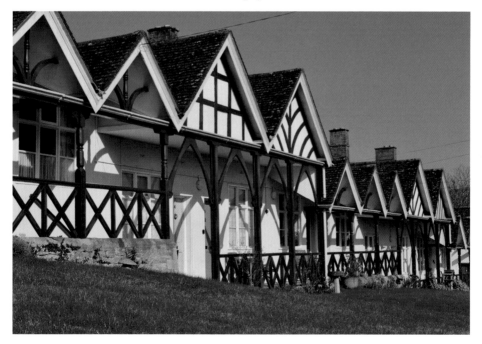

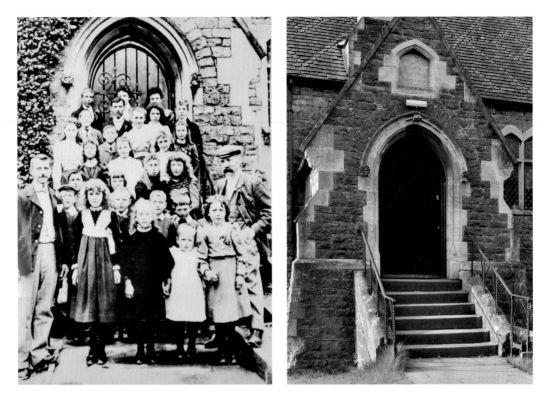

Roland Hill Memorial Sunday School

Across the road from the Tabernacle is the Sunday School Room, which was completed in 1852, with a main hall entered via the porch and a lower level with offices, kitchen and so on. Today, it provides additional space for the auctioneers, with a new mezzanine floor added for the books and pictures department. (WHS/JC)

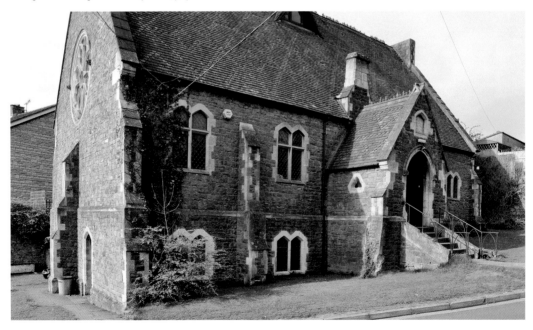

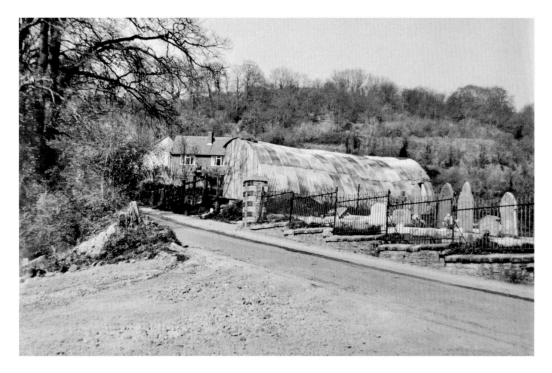

Tabernacle Road

The road used to run all the way up to Old London Road, although the upper part is now only a footpath. This view is just up from the Tabernacle, with the top of the church graveyard visible. Off camera on the left is Bank Yard, a gathering of small industrial/commercial units. The old farm building, *shown above*, has gone to make way for more houses. (WHS/JC)

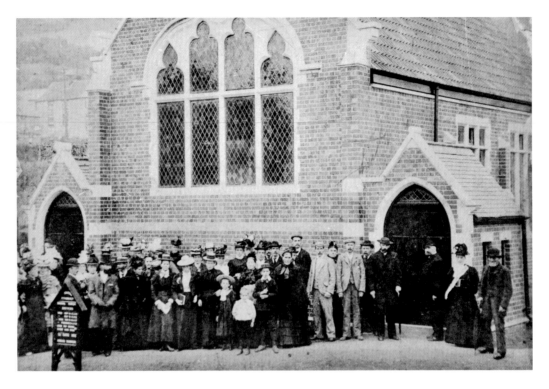

The Baptist Church, Bradley Street

The present building in Bradley Street was built to replace the previous chapel in Haw Street, and the old photograph shows the opening ceremony on 5 October 1898. The congregation later joined with those from the Tabernacle and it is now known as Wotton United Church. More than a century later, it appears little changed, although it was extended in 2000. (WHS/JC)

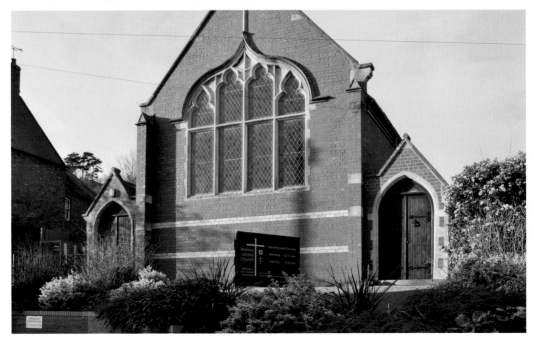

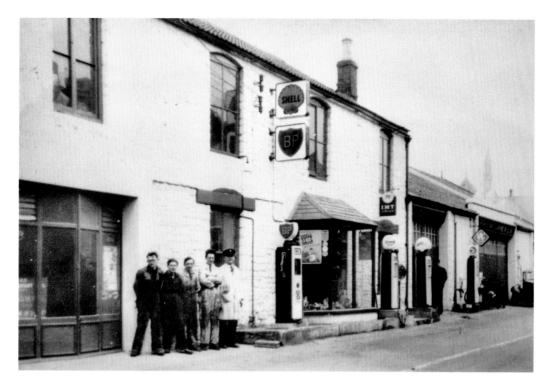

Bear Street Garage

Now that the garage in Gloucester Street has gone, to make way for new houses, the one in Bear Street is the sole petrol station in town. Frank James and his staff are shown with the roadside pumps and, *below*, we see the modernised garage and showrooms. Extra space has been gained at the far end, where the British School once stood on the corner. (WHS/JC)

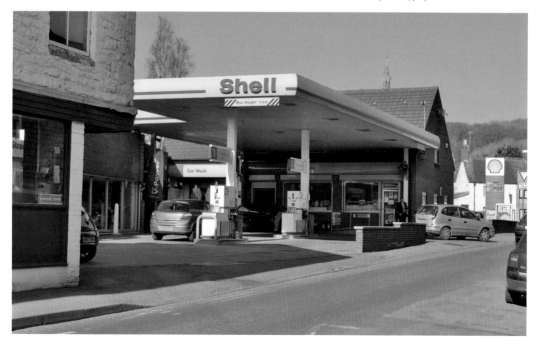

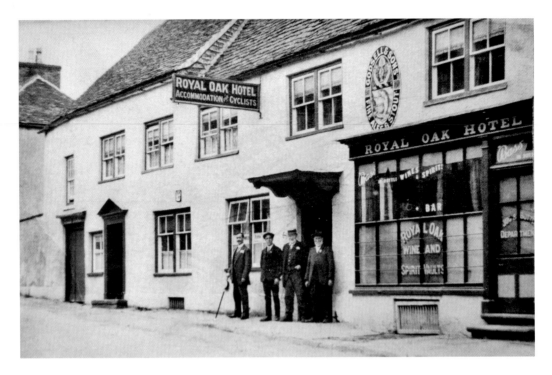

Royal Oak Hotel, Haw Street

At one time, Wotton had more public houses than it had churches – around sixteen in all. Today, there are only six remaining, including the Royal Oak on Haw Street. Note the sign, which offers 'Accommodation for Cyclists' and the Jug and Bottle Department, on the right, which is now incorporated within the bar. Godsell & Sons was acquired by the Stroud Brewery Company in 1928. (WHS/JC)

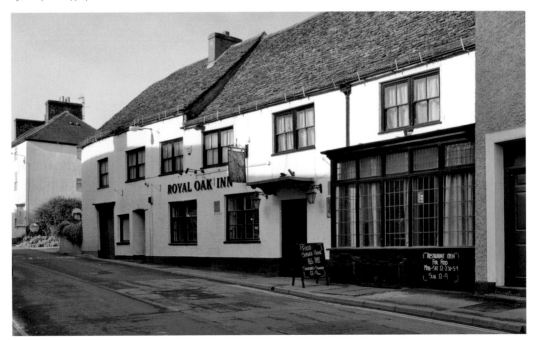

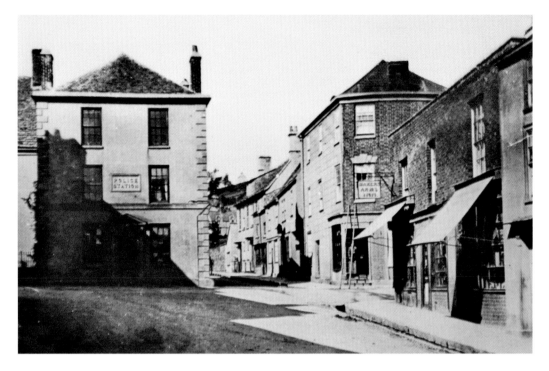

Bradley Street from the top of High Street
The pink house is the former police station, and it is still possible to make out the wording on a panel above the doorway. The former shop building on the other side of Bradley Street has been massively altered to create offices at the back of the Civic Centre. In the earlier photo, the Baker's Arms occupies the corner premises at the top of High Street, now an estate agents'. (WHS/JC)

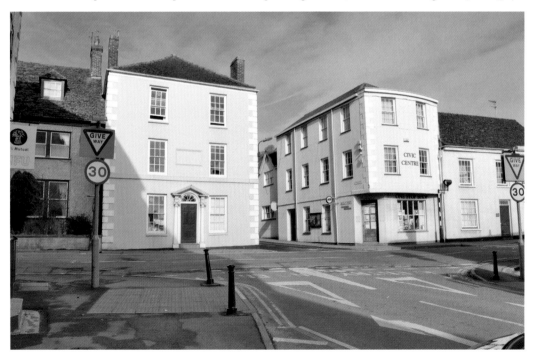

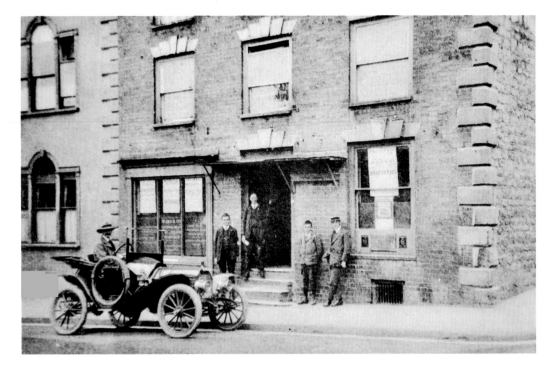

High Street

A rather stylish but unidentified make of car, possibly an American import, outside the High Street Chambers on the corner of Haw Street, *c.* 1910. These were the premises of F. W. Fry at that time, now offices for the NFU – the National Farmers Union. The Wotton branch of the NatWest bank is next door. (WHS/JC)

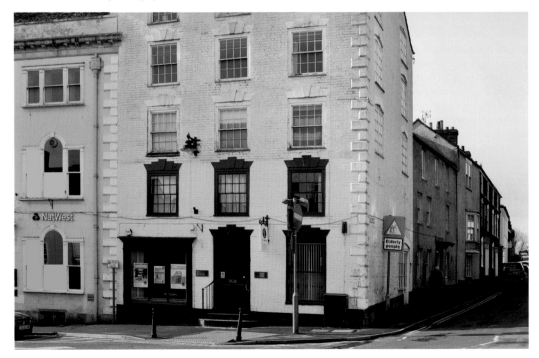

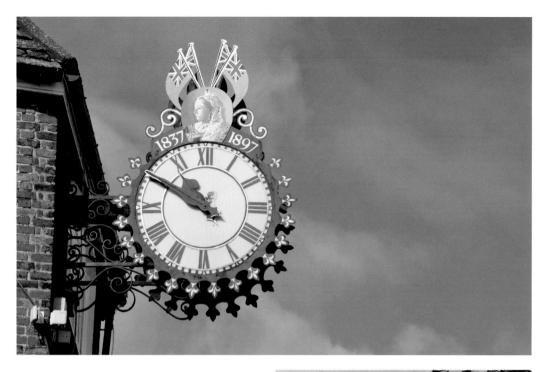

The Jubilee Clock

Above: Visitors can't fail to notice the clock that juts from the upper storey of the Tolsey House, on the corner of High Street and Market Street. Like many towns, Wotton went to great lengths to celebrate Queen Victoria's Diamond Jubilee, in 1897, and the clock remains as a lasting memorial to her reign. The coronation of her grandson, King George V, was marked by a procession marching through the town, *right*. Tolsey House is now privately owned, but the clock is the property of the town council. While not always accurate, it is a much-loved Wotton icon. (JC/WHS)

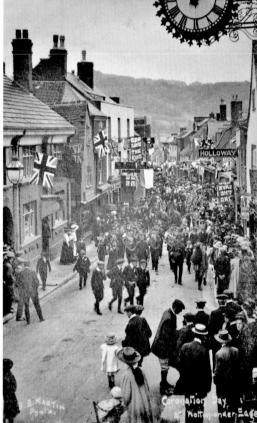

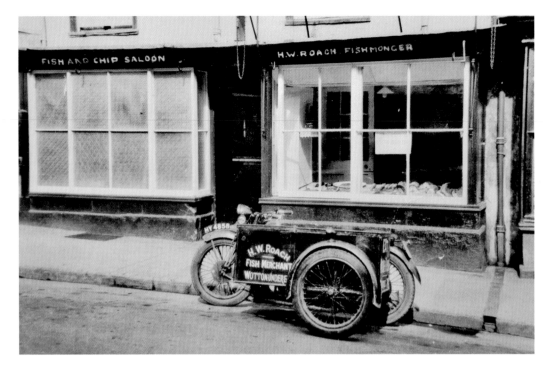

W. H. Roach Fishmonger, 5 High Street

In 1933, W. H. Roach, the Fishmonger, obviously thought his new delivery motorcycle worthy of a photograph. The window display might seem low-key by modern standards, but Mr Roach was clearly an enterprising chap and had expanded his business with a Fish and Chip Saloon next door. The fishmonger's is now the pet shop and so the fishy theme is still evident. (WHS/JC)

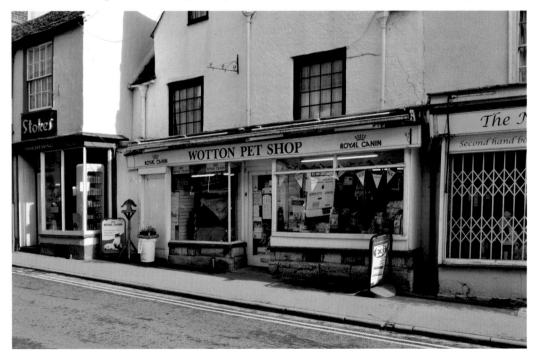

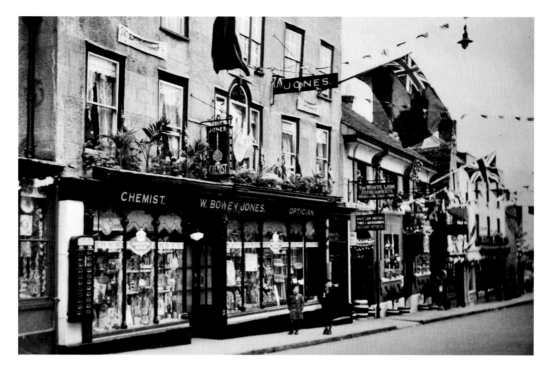

W. Bowen Jones, High Street

Another royal occasion and yet another photograph, this time to mark Queen Elizabeth's coronation in 1953. W. Bowen Jones, the Chemist, occupied one of Wotton's most imposing premises on High Street, facing into Market Street. It is now R. A. Bennett & Partners, one of several estate agents in the town. (WHS/JC)

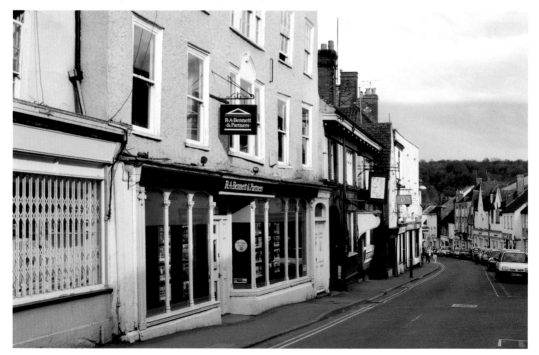

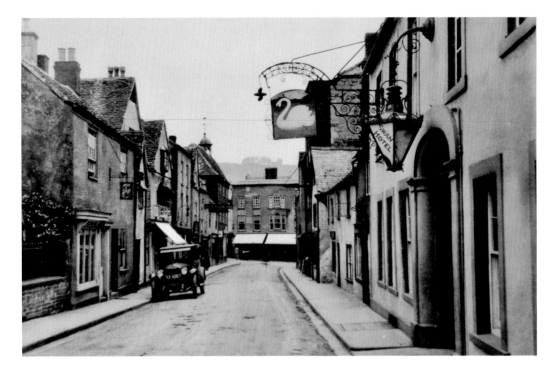

Market Street

At one time, Market Street was one of the most important streets in Wotton, with the old coaching inn, the Swan Inn, the Town Hall and several shops including Jethro Hunt's shoe makers and repairers. Gradually, the shops in Market Street disappeared and many were converted to homes or offices, but it does have a thriving cinema nowadays. (WHS)

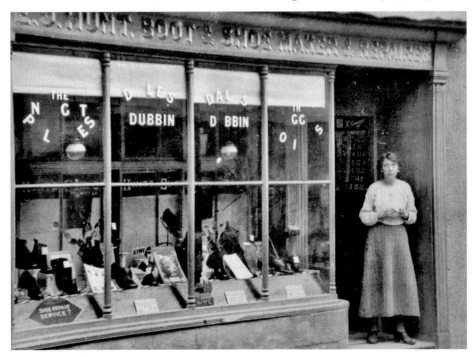

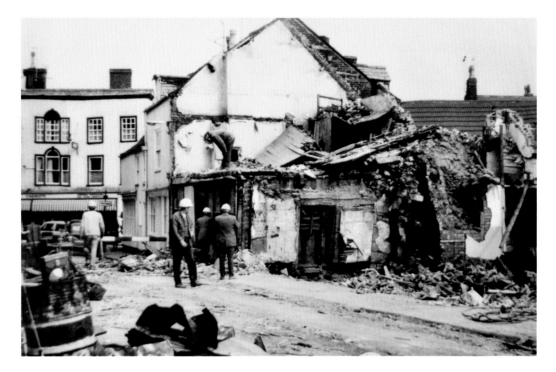

Market Street rebuild

No, this is not the result of an air raid. By the mid-1970s, several of the buildings on the east side of Market Street had become unsafe and were knocked down and rebuilt from scratch. The casual observer would never notice the difference. Proposals to create an archway leading to a car park area at the back never materialised. (WHS/JC)

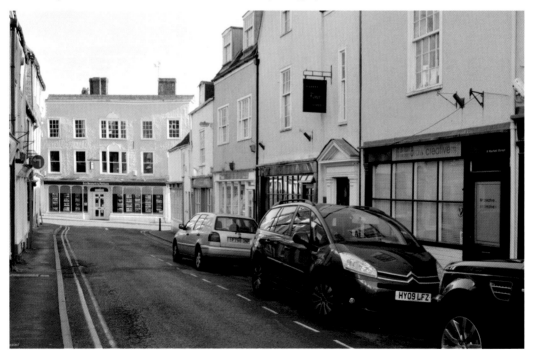

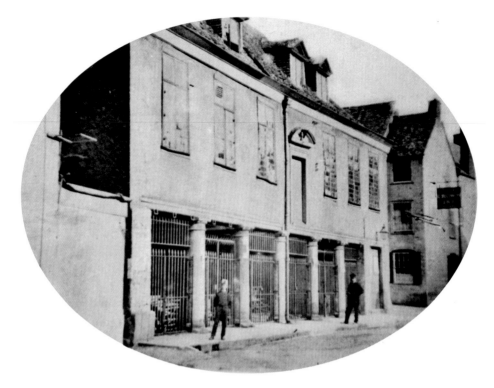

Market Street and the Stoney Chipping
Wotton's Town Hall stands right next to the Swan Inn and opposite the Star. The open area where the road widens is all that remains of the old Stoney Chipping, where the market was once held. The Town Hall was originally built as a market house, standing on Doric columns to create a covered market area. Similar market houses can be found in the centre of Tetbury and Dursley. (WHS)

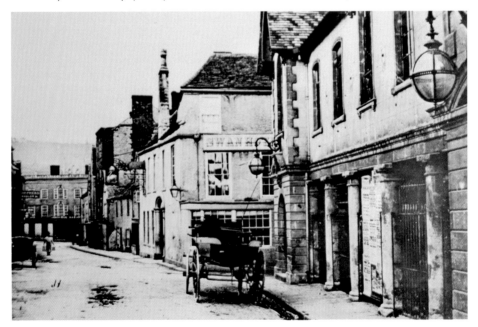

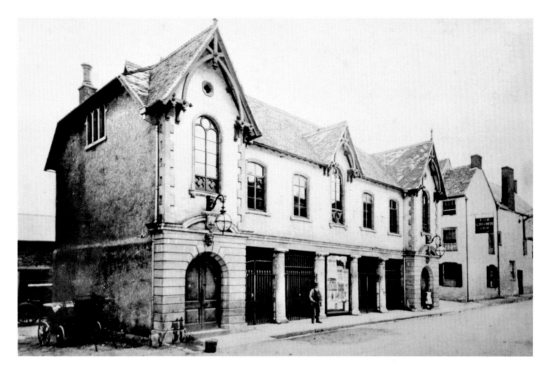

Town Hall, Market Street

The open part of the Town Hall was enclosed in 1872, and further alterations were carried out in 1884 that give the building's exterior its Victorian flavour. The ground floor is now fitted out to provide space for events, such as the famous Town Hall Teas, while the upper storey remains as an auditorium or hall for bigger events. (WHS/JC)

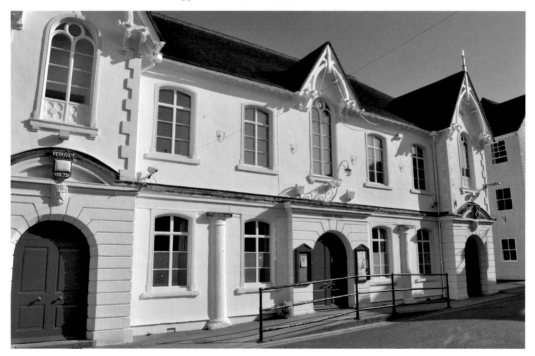

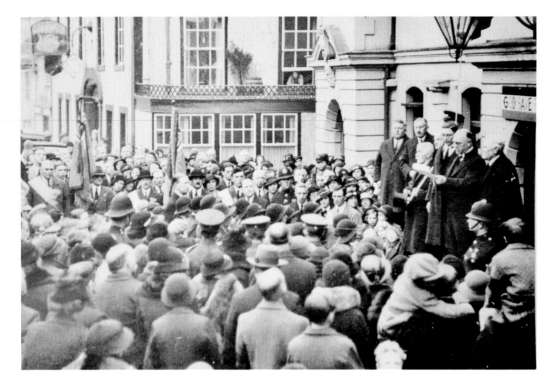

Town Hall pronouncements

The Town Hall was the tangible symbol of civic pride and the focus of public events. It was a sombre crowd that gathered here, in January 1936, to hear the mayor officially announce the death of King George V and the accession of his son Edward VIII. One of the shortest reigning monarchs in English history, Edward announced his abdication only 325 days later. (WHS/JC)

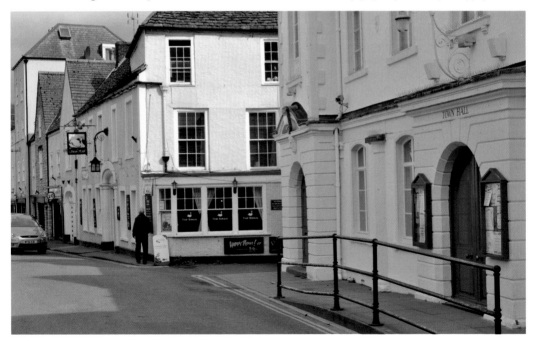

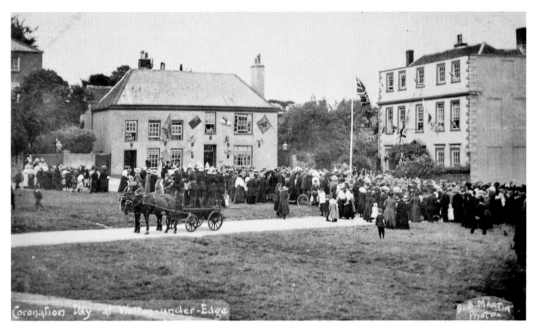

Coronation Day at Wotton-under-Edge

The Chipping

This open area at the end of Market Street is mostly known by locals as the main car park nowadays. The name Chipping denotes a market space, and on occasions this has been a place for public gatherings, such as the Coronation Day celebrations held for King George V on 22 June 1911. Note the horse-drawn fire pump carrying the Wotton firemen – every one of them by the look of it – resplendent in their shiny brass helmets. *See p. 48.* (WHS/LoC)

See p. 48.

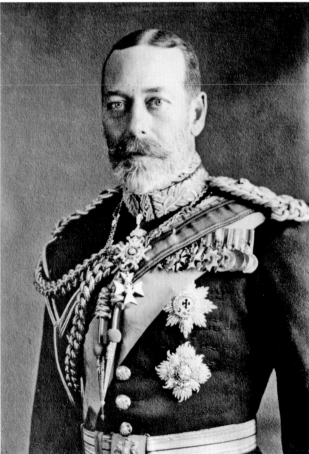

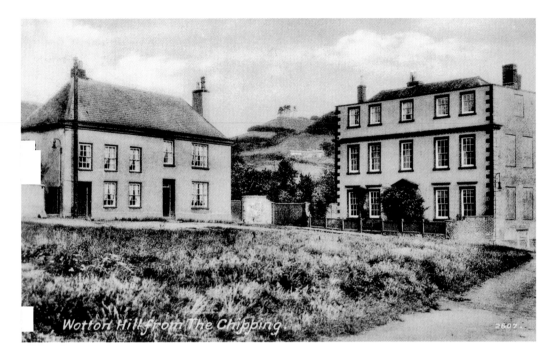

The Chipping

Well House and Chipping House, on the western side of the Chipping, with Wotton Hill in the distance. Chipping Manor is out of shot on the left-hand side. The well at Well House had been an important source of water, but was closed in 1854 following an outbreak of cholera. Since then, Well House has lost its front garden and become offices, the builders' yard is in the gap in the middle, and Chipping House is a B&B. (JC)

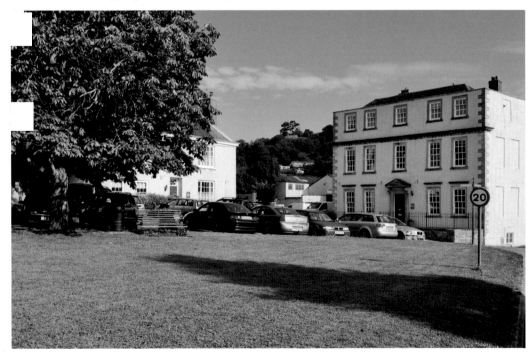

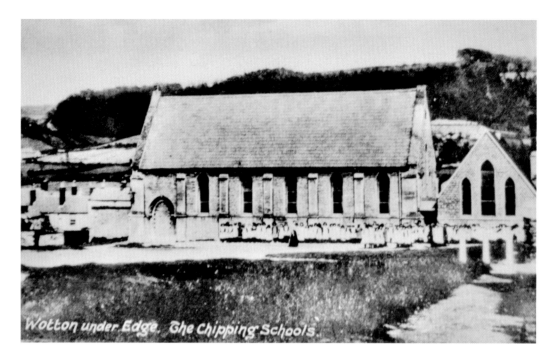

The Chipping School

Now used by Under the Edge Arts, the old school building on the Chipping is the former home of the National School – the name is displayed in relief panels on the gable end. Constructed in the 1830s, it incorporates a magnificent doorway taken from Kingswood Abbey. Look out for the graffiti scratched into the wall by a bored American serviceman in 1944. The smaller side hall is an infant room added in 1876. (JC)

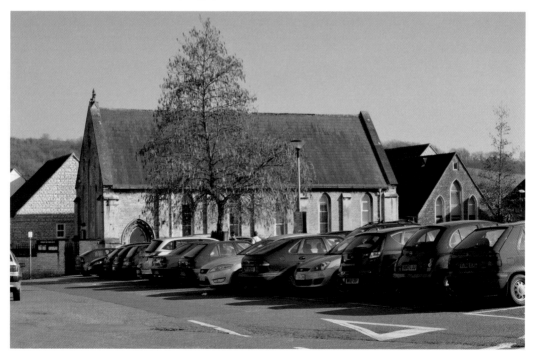

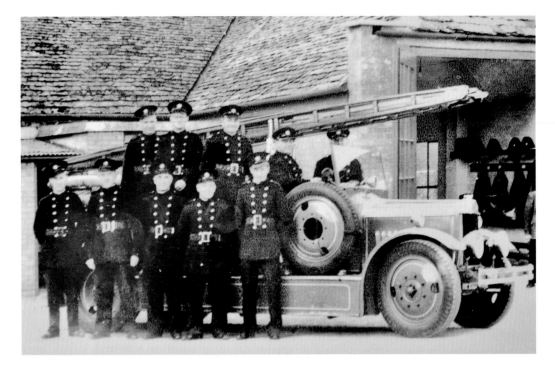

Fire engines ...

Looking very proud with their 1929 Dennis fire engine, Wotton's firefighters pose in front of the old fire station on the Chipping. This motorised pump was a vast improvement on the old horse-drawn, hand-powered pump – *see p. 48*. The modern equivalent is shown attending a fire behind the commercial units at Bank Yard, off Tabernacle Road, in 2011. (WHS/JC)

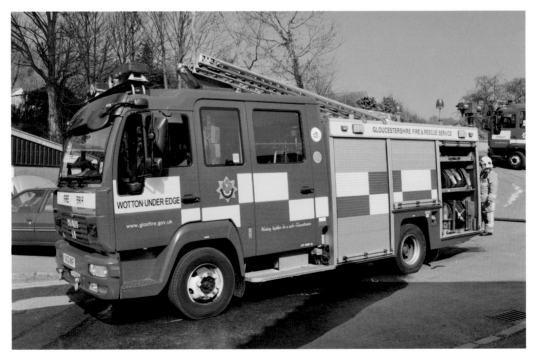

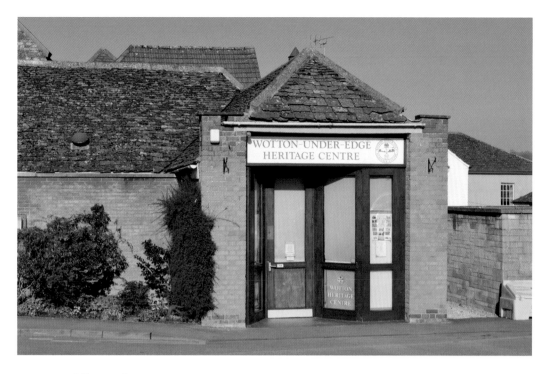

... and fire stations

The old fire station on the Chipping is currently serving as the Wotton Heritage Centre, although there are proposals for the Wotton Historical Society to take on the Library premises off Ludgate Hill. The new fire station, on the edge of the town, is at the top of Symn Lane and has one of the finest views of any fire station in the country. (JC)

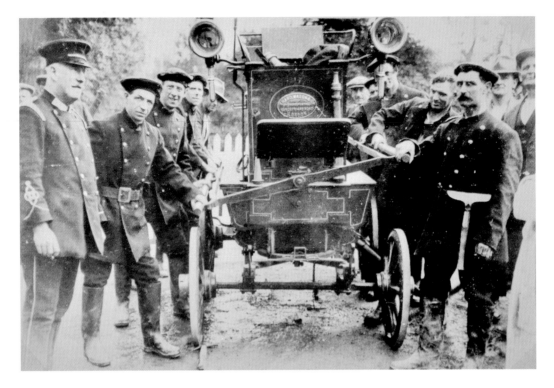

Firefighters

A fabulous photograph of Wotton's voluntary firefighters, posing with the 'Jubilee Engine', after tackling a blaze at Terrett's Mill, Kingswood, in 1927. Some of the current crop of retained firefighters stand behind a similar hand-pump kept at Wotton fire station, although this particular example actually belonged to the Dursley brigade. (WHS/JC)

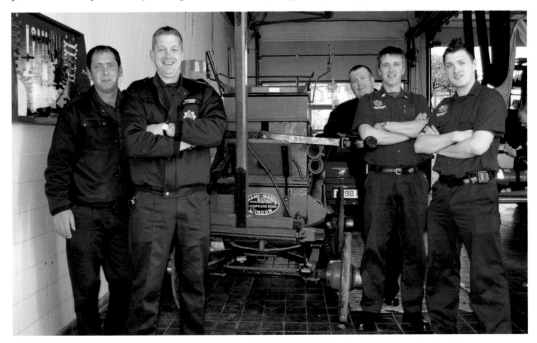

The long arm of the law

Not to be left out, a photograph of Wotton's boys in blue. The police station has been located variously at the top of High Street, on the corner with Haw Street – complete with its own Magistrate's Court – then in Dryleaze and is now on the Chipping, next to the Chipping Club Room. The new houses, to the right, are part of the Beaumont Square development on the former site of the Secondary Modern/Blue Coat School. (WHS/JC)

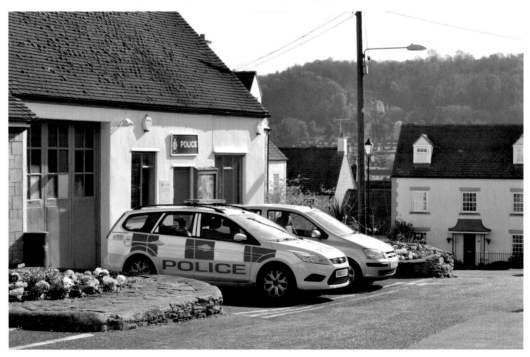

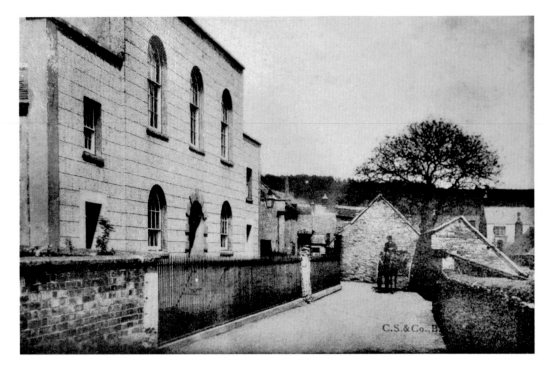

Baptist Chapel, Rope Walk

The Rope Walk links the Chipping with Long Street. The present Baptist chapel opened in 1816, although its styling reflects a more Georgian influence. A Baptist ministry had been active in the town for almost a hundred years before that, with a chapel formerly located on the site of the Grammar School. (WHS/JC)

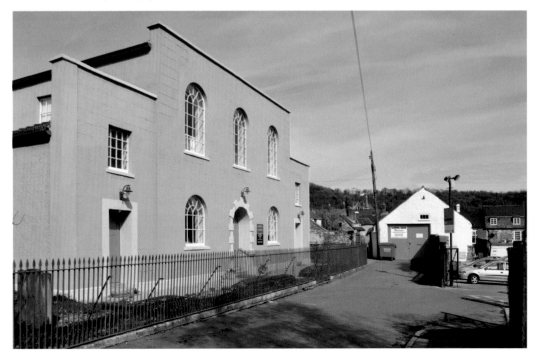

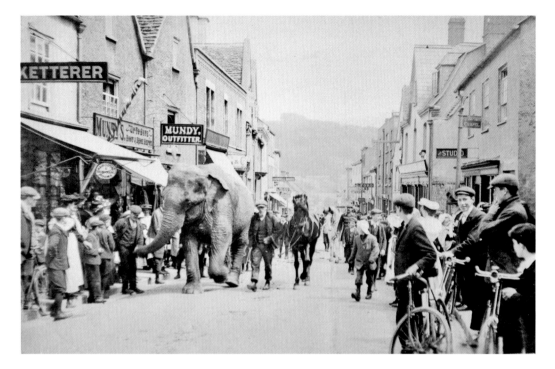

An elephant tusk force

No book of old photographs would be complete without an appearance by an elephant. The reason for this pachyderm's parade, up Long Street in around 1907, is probably to advertise the arrival of a circus in the neighbourhood. His modern counterpart would have to avoid the ever-present parked cars. (WHS/JC)

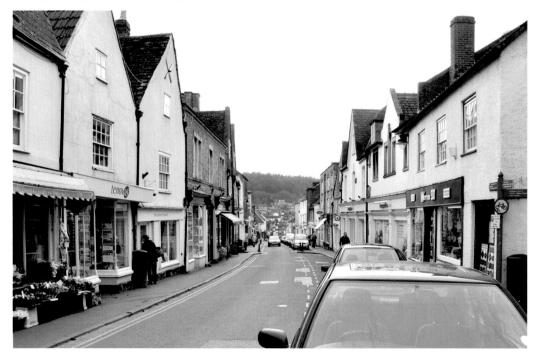

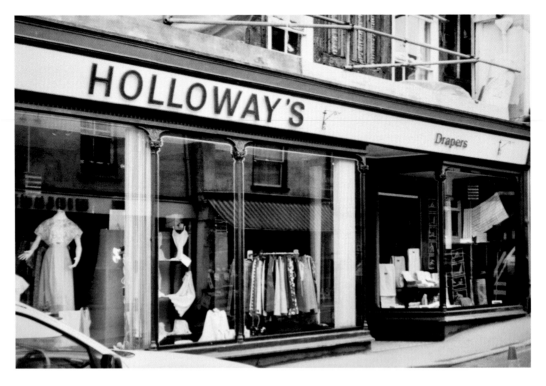

Long Street shops

The times when you could buy anything you needed without leaving the town have mostly gone. Holloway's was one of Wotton's best-known retailers, but as a sign of the changes over the years their drapers shop at No. 48 Long Street is now the Fusion Gallery. (WHS/JC)

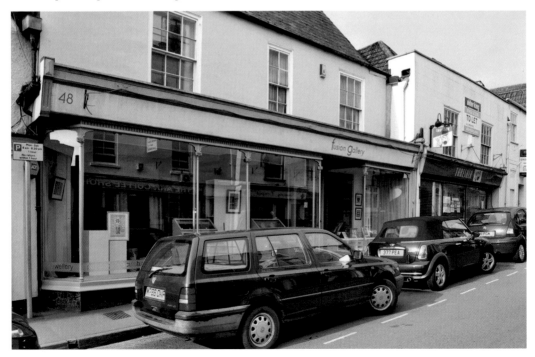

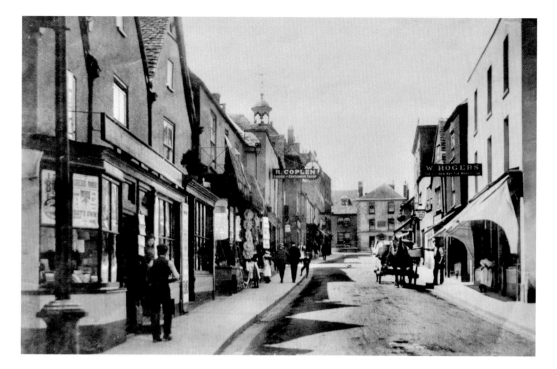

Looking up Long Street

Just up from the entrance into Rope Walk, looking up Long Street towards High Street, the individual traders may have come and gone but the buildings have hardly changed. More obviously, a lone horse-drawn cart has given way to a perpetual line of parked cars. (WHS/JC)

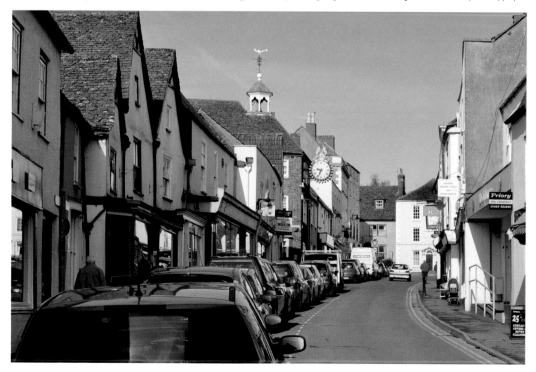

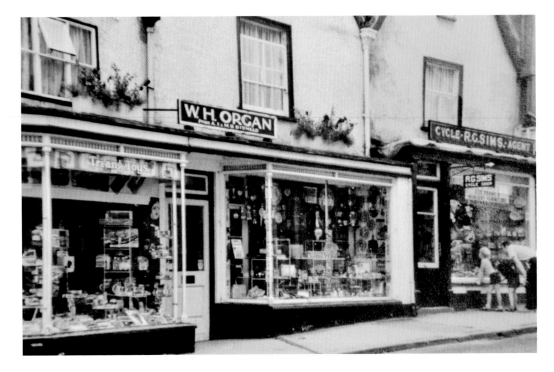

Boy's toys

Today, it is McQuiggs Café Bar and Restaurant. In the 1970s, W. H. Organ's shop on the south side of Long Street was still a honey pot for children, with its enticing display of Triang toys, Airfix plastic kits and all manner of fancy goods. Next door, a couple of young lads pore over the contents of Reg Sim's cycle shop – *see p. 74*. (WHS/JC)

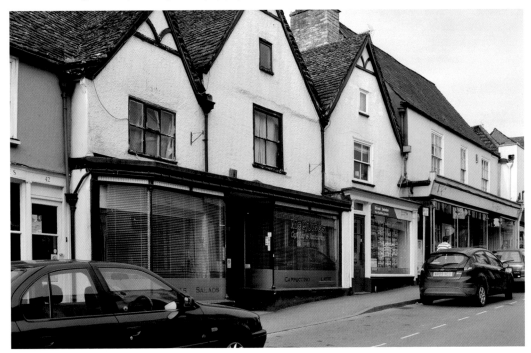

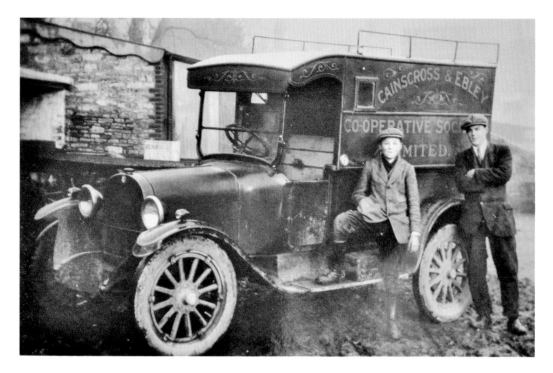

Boy racers
A likely pair of boy racers pose beside their Cairncross & Ebley Co-operative Society delivery van, at the rear of Wotton's Co-op store off Rope Walk, probably in the late 1920s or early 1930s. The notion of home deliveries has come back into fashion thanks to online shopping, and there is a Co-op van parked in the same spot today. (WHS/JC)

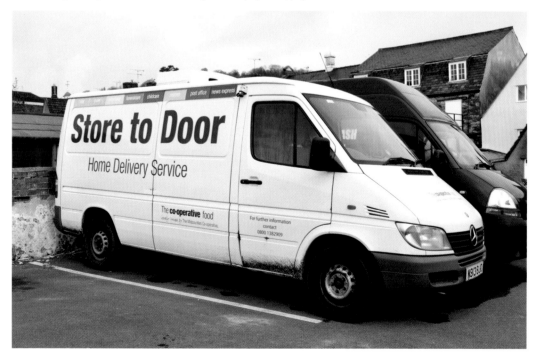

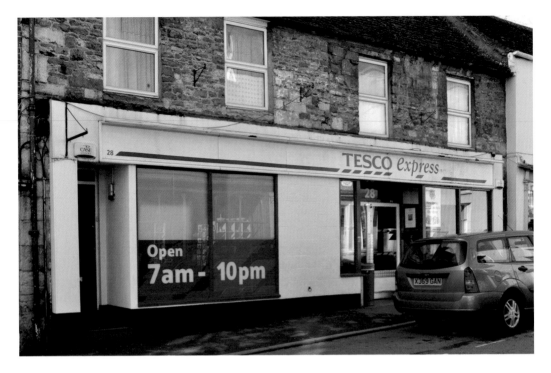

Groceries and provisions

In the interest of fairness, Wotton does have another supermarket – at least a mini-version in the form of Tesco Express. This continues the tradition of selling groceries from this site, as shown in the *c.* 1905 postcard of Portlock's Stores. The old shopfronts have gone and the stonework has been exposed, but the building can be identified by the upper windows. (JC/C.McC)

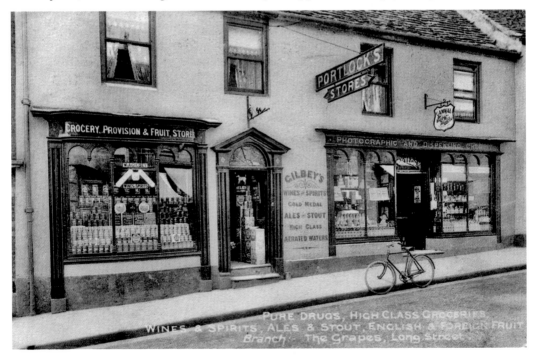

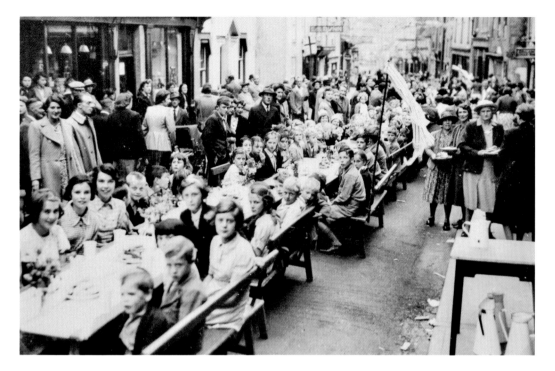

Street parties

In 1945, the children of Wotton celebrated VE Day with a party that stretched the length of Long Street. It's a custom that has been repeated on other special occasions, including the fiftieth anniversary of VE Day in 1995 and, most recently, the marriage of Prince William to Catherine Middleton in April 2011. (WHS/JC)

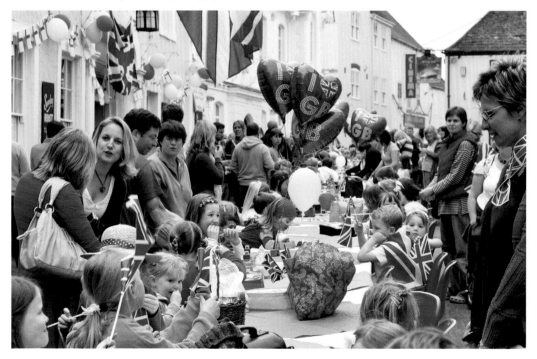

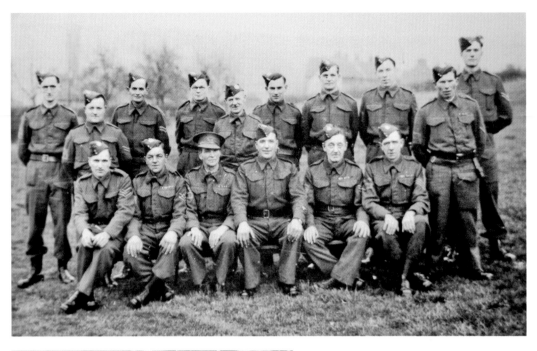

The Home Guard

On the subject of the Second World War, mention must be made of the Local Defence Volunteer force, the LDV, which was created in 1940 as part of Britain's last-ditch efforts to defend against an expected Nazi invasion. Later renamed the Home Guard, 1.5 million men otherwise unavailable for military service answered Churchill's call for volunteers. Because of their age, they are affectionately referred to as 'Dad's Army', but make no mistake, if push had come to shove they would have done their bit. The Heritage Centre has several Home Guard artefacts as part of its display on the Second World War, and the men of the Wotton and District Home Guard are shown in this photograph, *above*. (WHS/JC)

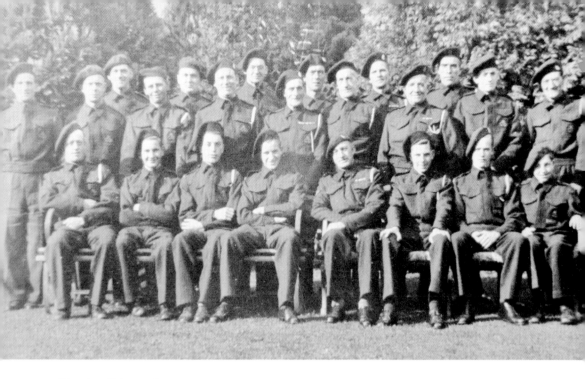

'Put that light out!'

It wasn't only the Home Guard who did their bit on the Home Front during the war. Shown above are the local ARP (Air Raid Precautions) wardens, who were responsible for the issuing of gas masks, arranging air-raid shelters and maintaining the blackout. Hence their cry of 'Put that light out!' This group of Special Constables, *below*, was photographed on the bank outside the White Hart in North Nibley. (WHS)

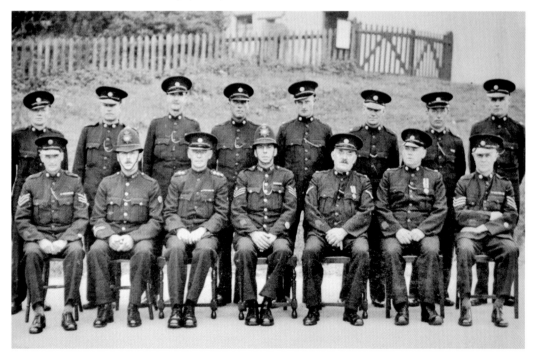

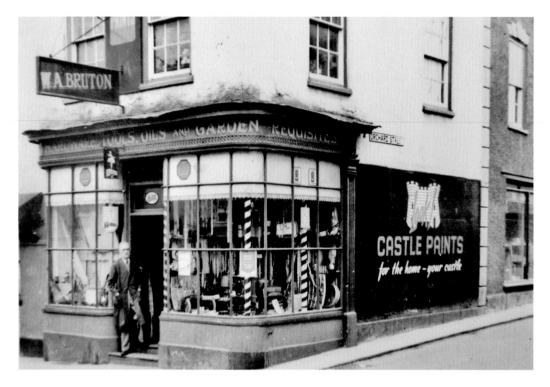

Long Street and Orchard Street

Further down Long Street, we come to the junction of Orchard Street. On the corner is the elegant curved glass window of Mungo's, which used to be W. A. Bruton's store, offering 'Hardware, Tools, Oils and Garden Requisites'. Next door is the post office, which has moved home time and time again. (WHS/JC)

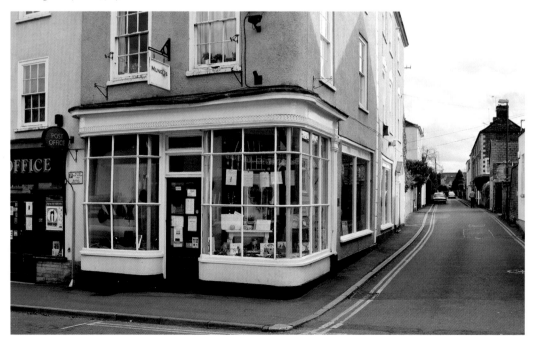

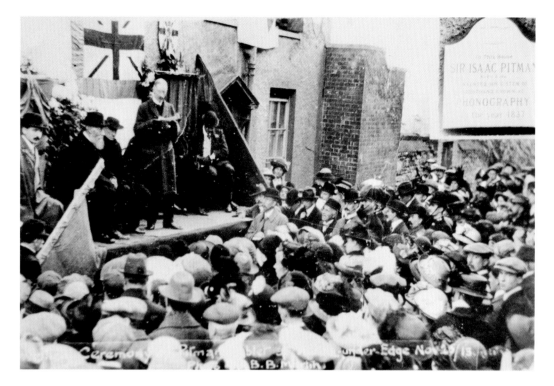

Pitman's place

Isaac Pitman was the Wotton school-master who gained international fame for devising a system of shorthand, or phonography, known as Pitman Shorthand. He was knighted in 1894, died in 1897, and the inhabitants of the town applied a commemorative plaque to his house in Orchard Street in 1913. They also named Pitman Place in his honour. (WHS/JC)

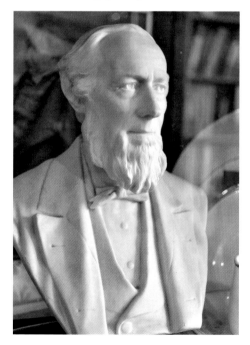

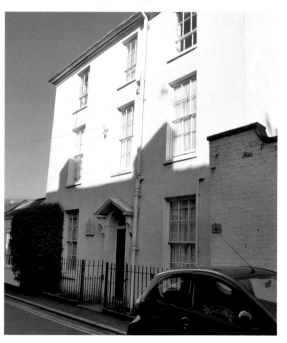

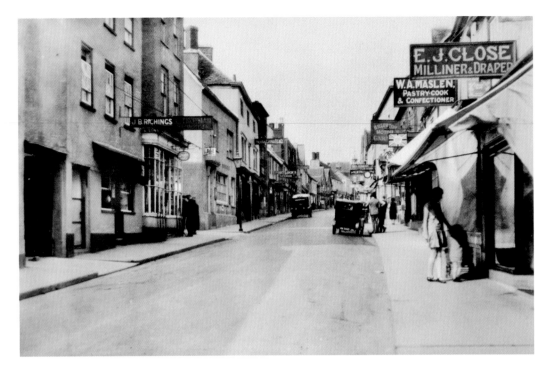

The lower part of Long Street

Looking back up Long Street again, this time with Orchard Street branching off on the left. It is interesting to see the plethora of shop signs jutting from every building. Note H. Lewton's Motor Garage on the right-hand side – *see p. 73*. The shop signs have been tidied up, but the once-empty street is now cluttered with parked cars thanks to the likes of Mr Lewton. (WHS/JC)

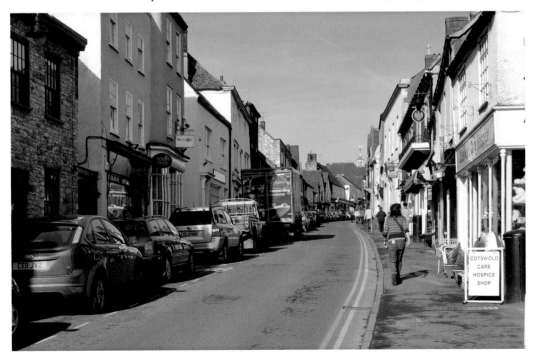

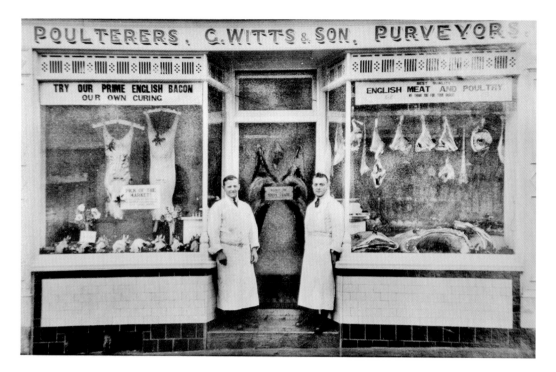

From chicken to Chick King

So many of Wotton's old shops have been converted to homes that they are barely noticeable. At the bottom of Long Street are the former premises of G. Witts & Son, Poulterers and Purveyors, which is interesting, because for a while in the 1990s it was Chick King, purveyors of fast food. (WHS/JC)

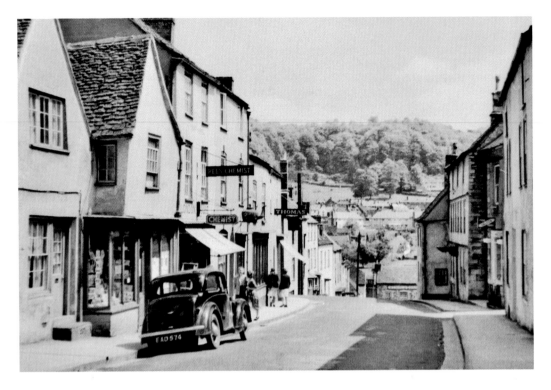

Lower Long Street

The bottom of Long Street, with Thomas's on the corner and looking down towards Ludgate Hill. The car is parked next to what is now the bike shop. It appears to be facing the wrong way, as Long Street now has one-way traffic going up the hill to the High Street. The teapot sign is still there, despite some recent rebuilding on that side of the street. (WHS/JC)

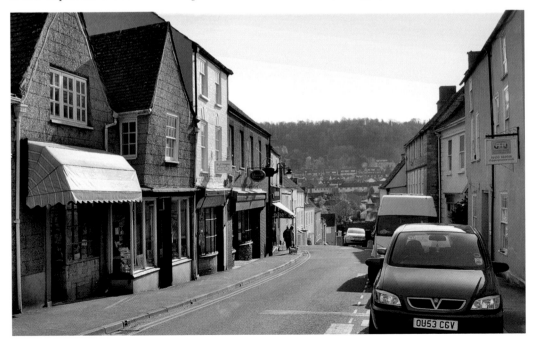

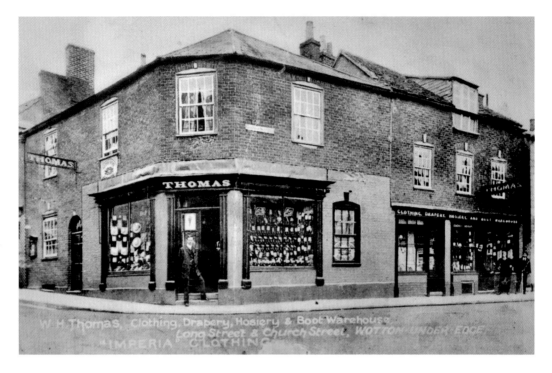

Thomas's outfitters

Situated on the corner of Church Street and Long Street, W. H. Thomas & Sons is one of the oldest family-run businesses in Wotton, and was established over a hundred years ago now. More than any other shop in the town, it gives a flavour of what shopping in Wotton used to be like. The modern photograph shows some rebuilding of the premises on the Church Street side. (W. H. Thomas/JC)

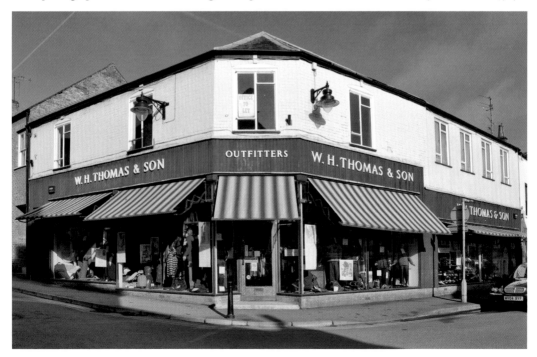

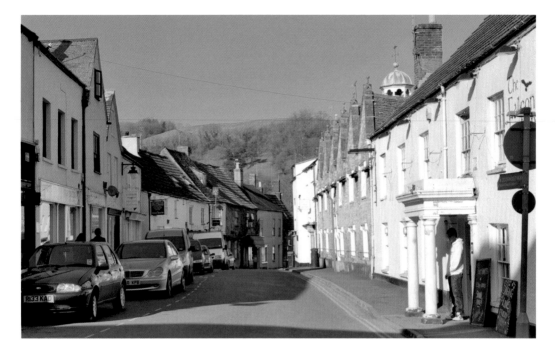

Church Street

This had its fair share of shops at one time, and a number still serve as hairdressers, restaurants and so on, but Church Street's most famous buildings, depending upon your interests, are the Falcon Inn and its immediate neighbour the Perry and Dawes Almshouses. The latter were built in two stages; the first by Hugh Perry in the seventeenth century, added to by Thomas Dawes in the eighteenth. (JC)

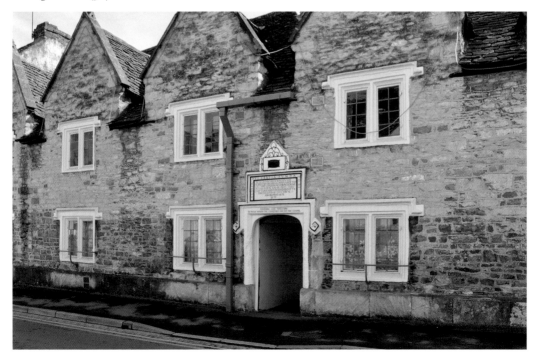

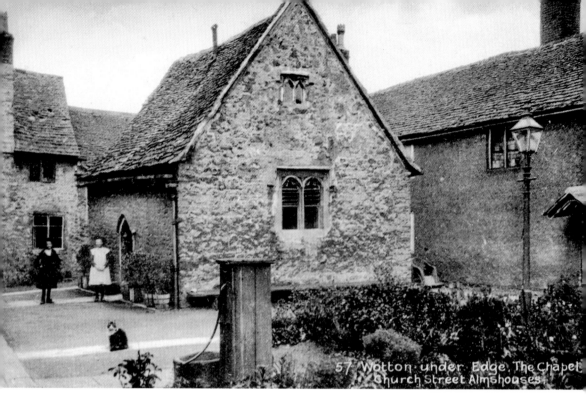

57 Wotton-under-Edge. The Chapel Church Street Almshouses

Perry and Dawes Almshouses, Church Street

Visitors are welcome to enter through the passageway into the quiet courtyard to see the tiny seventeenth-century chapel. Since this postcard was published in the early 1900s, the old chapel has hardly changed at all and the almshouses have seen only minor modifications. (JC)

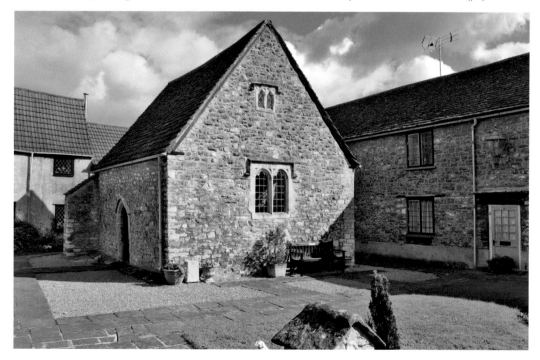

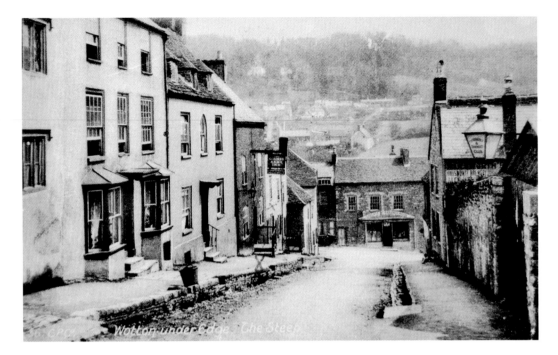

Ludgate Hill

A hundred years ago, this was known simply as The Steep, a much more appropriate name for this seriously inclined road. It appears to be the drinking centre of Wotton, with its pubs and signs for Nailsworth Brewery, plus at the bottom of the hill there is the Ludgate Co-op Branch House, which later became the Shearman's Arms. (WHS/JC)

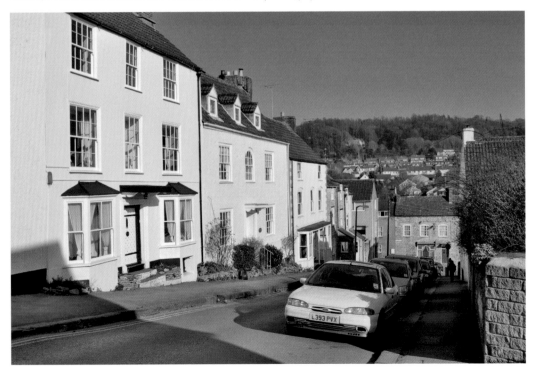

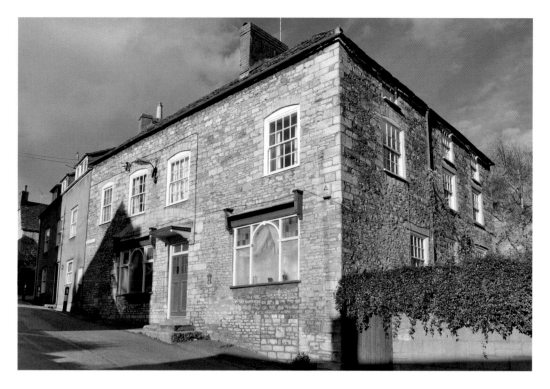

Shearman's Arms, School Road

The former Cairnscross & Ebley Co-operative Society Ludgate No. 4 Branch House, at the bottom of Ludgate Hill on School Road, still shows evidence of its time as the Shearman's Arms public house, although today it is a private dwelling. Typically, for Wotton, you only realise how steep the hill is when you see it in the photographs. (JC/WHS)

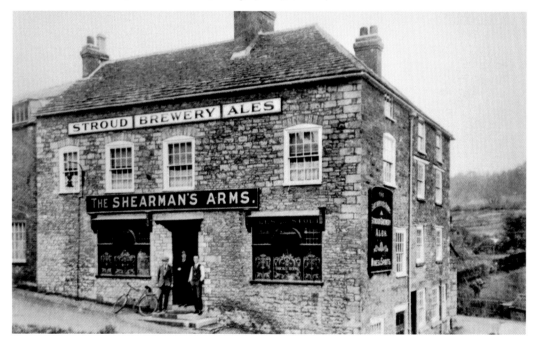

Transport

The single greatest and most obvious change on the streets of Wotton over the last one hundred years or so has been the shift from horse power to horsepower. Before the advent of the internal-combustion engine, the vast majority of the town's inhabitants were unlikely to have travelled any further than the next village. Cities such as Bristol, Bath and Gloucester could have been on the other side of the Moon as far as they were concerned. The revolution in transportation has changed all that. It has brought unprecedented personal mobility on the one hand, but has also irrevocably altered the shape of our rural towns forever. The car has brought new freedom. Freedom to shop where we choose, send our children to any number of schools regardless of location, and enabled many of us to work far from where we live. As a consequence, cars fill and empty the new estates like the daily ebb and flow of the tides. The town was never designed to cope with modern levels of traffic, but it will adapt as best it can to the inevitable changes that come with time.

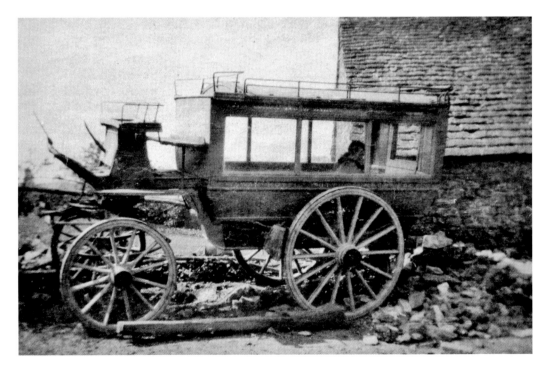

This horse-drawn bus conveyed travellers between the railway station at Charfield and the Swan Hotel in Wotton. At one time, there were six wheelwrights and coach builders working in the town. (WHS)

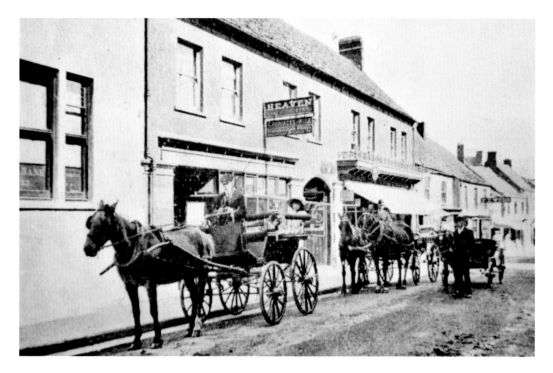

Wotton's transport hub
Not a car in sight. Carriages outside the offices of Heaven's coach services, half way up Long Street, *c.* 1903. 'Carriages for Hire', says the sign. They also ran services to Charfield and elsewhere. The premises are now a jewellers and watch repairers, with banks to either side – Lloyds to the left and Barclays just beyond the archway – *see p. 73.* (WHS/JC)

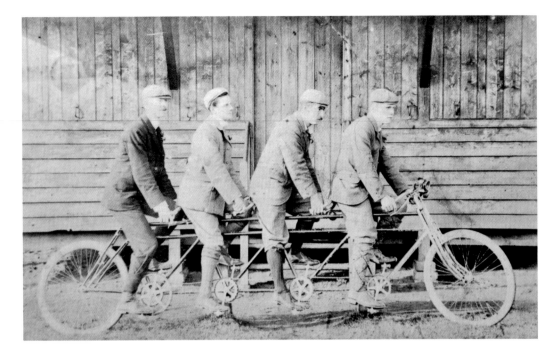

Cycle power

In Edwardian times, cycling became a popular pastime and these gentlemen from Wotton liked to travel as a foursome. Unfortunately, the arrival of the motor car made cycling on the country roads an increasingly hazardous activity, as depicted in this contemporary cartoon from the pages of *Punch*. Alarmed Motorist (after collision): 'Are you hurt?' Butcher Boy: 'Where's my kidneys?' (WHS/JC)

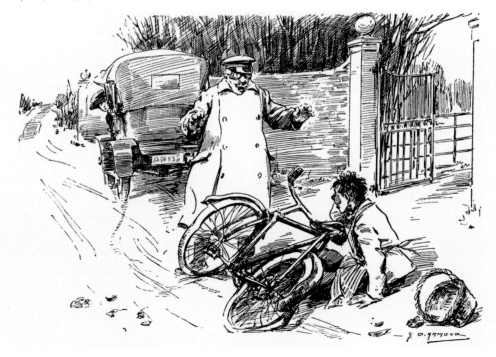

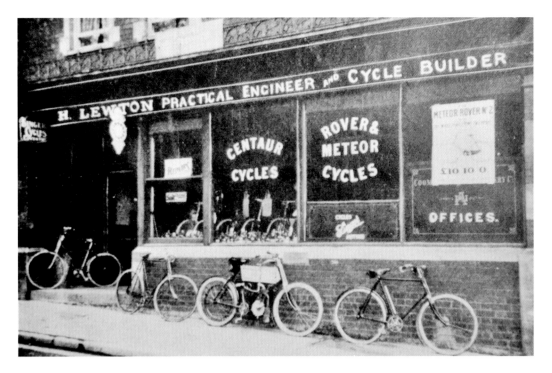

H. Lewton – Practical Engineer and Cycle Builder

The first decade of the twentieth century saw a move away from the horse to other forms of transport. Lewton's had stocked bicycles made by Centaur, Rover and Meteor, but the Rover company went on to build cars, so Lewton's installed petrol pumps in the archway and converted the premises behind the shop to create Wotton's first garage. *See p. 77.* (WHS/JC)

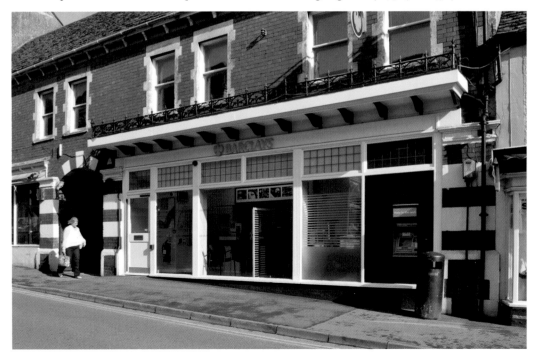

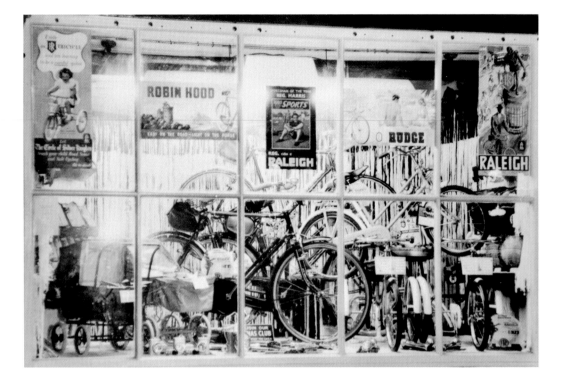

Bike shops

A wonderfully nostalgic image of a bike shop window – probably from the 1960s judging from the styles – at Reg Sims, which was situated on the south side of Long Street just up from Rope Walk. You can just imagine the nose-marks left by countless children pressing against the glass. Thankfully, we still have a bike shop in Wotton, further down Long Street at No. 7. (WHS/JC)

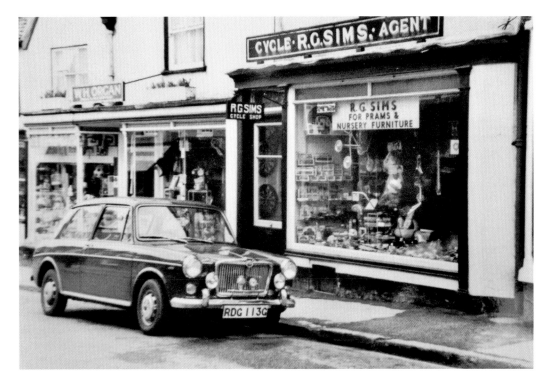

R. G. Sims Cycle Agent

By the 1970s, Reg Sims had diversified a little, and in addition to bikes he also offered 'Prams and Nursery Furniture'. It is not clear whether the smart MG 1100, bristling with motoring badges, belonged to the proprietor or a customer. The shop later became an estate agents' and is now a branch of the Stroud & Swindon Building Society. (WHS/JC)

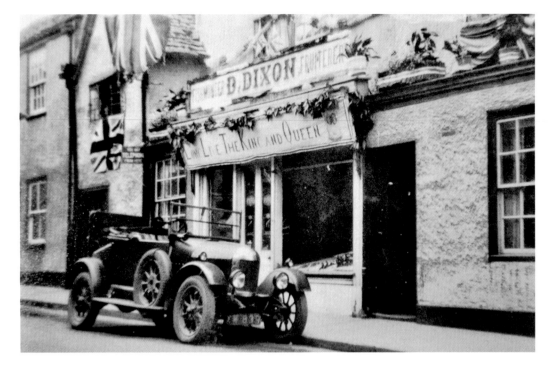

Market Street
A Bullnose Morris Cowley Royal stands outside the premises of D. Dixon Fishmonger & Fruiterer, in Market Street, in the mid-1930s. Royal occasions were always a time for photography and the shop is decorated to mark either the Silver Jubilee of George V, in 1935, or the Coronation of George VI the following year. It is now a private residence, and note the exposed beams on the neighbouring house. (WHS/JC)

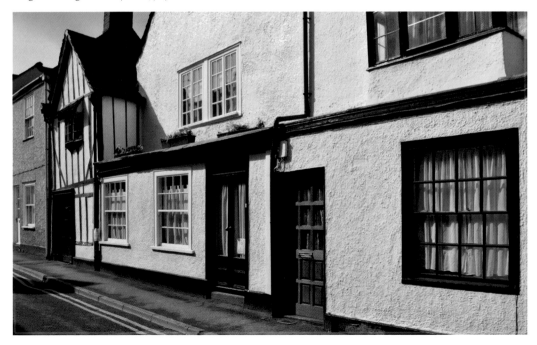

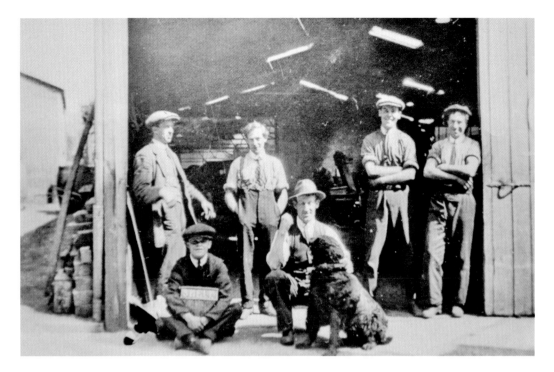

Wotton's garages

An informal image of mechanics taking a break at H. Lewton's garage, *c.* 1919, which was located behind the present Barclays Bank in Long Street – *see p. 73.* When Lewton's closed down, other garages were established in the town, including those at Bear Street and also in Bradley Street, *shown below.* (WHS/JC)

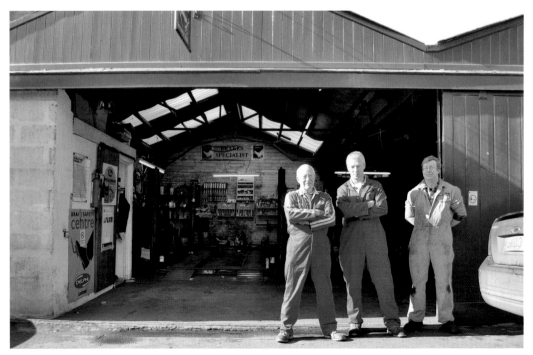

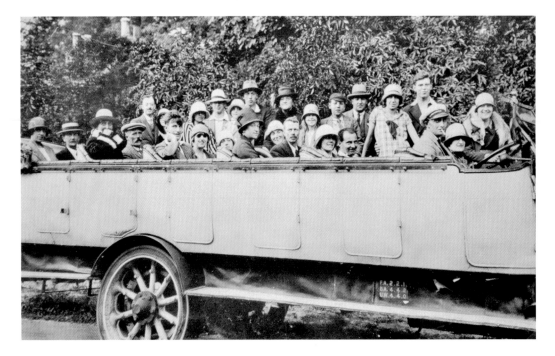

Public transport

A typical charabanc outing in the 1920s. The simple open-topped charabancs offered the opportunity for cheap and cheerful travel, taking local groups or societies on excursions to enjoy the seaside or other tourist spots not served by the public omnibuses. Motor buses came on the scene from around 1910, and the modern equivalent is this Stagecoach single-decker, waiting for passengers at the bottom of Old Town before it heads off to Nailsworth and Stroud. (WHS/JC)

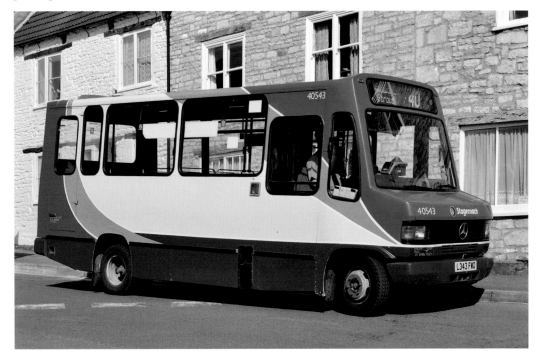

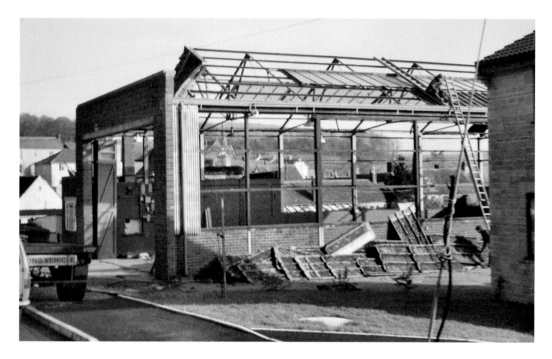

Bus depot and Charfield railway station

Wotton had its own bus depot at Westfields, which was demolished in 1984, *above*, and the site is now occupied by lock-up garages. However, the town is too hilly to be on a railway and the nearest station is at Charfield, *below*. In 1928, this was the scene of a terrible accident when a night mail train hit a goods train head-on. Fifteen victims, including two unidentified children, are buried in a mass grave in the churchyard. (WHS/JC)

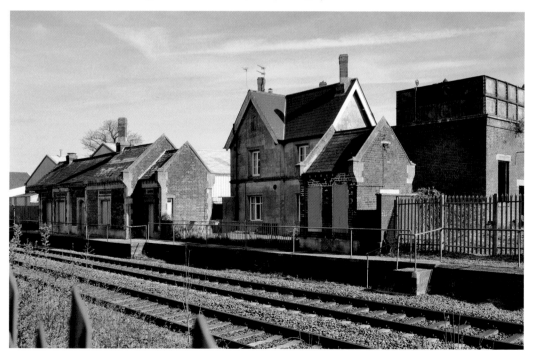

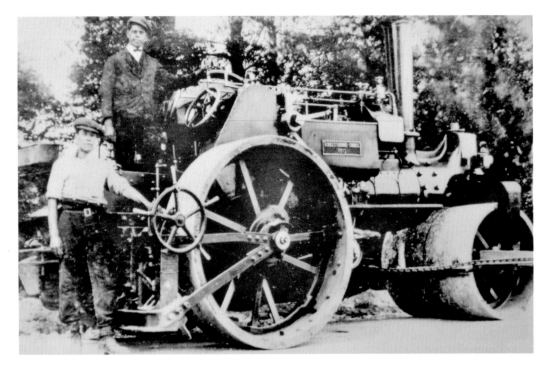

The age of steam lives on
In the upper picture, two Maunders brothers are shown working in 1920 with a county council steam roller built in 1913. Local resident, engineer and steam enthusiast Godfrey Shellard is keeping the spirit of steam alive in Wotton with this two-third-scale working steam engine, which he has designed and built himself over a period of two years. (WHS/JC)

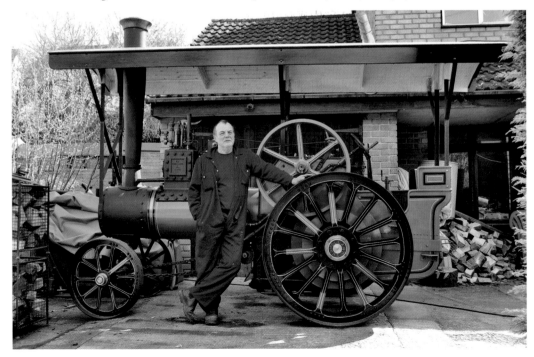

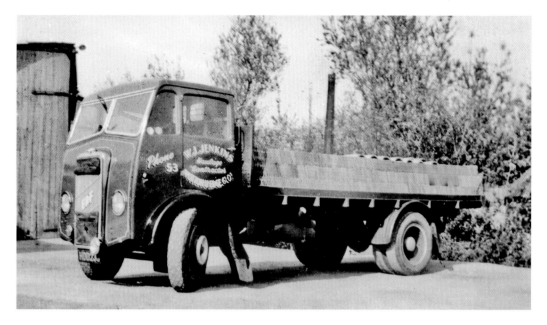

Road haulage

There are no road haulage companies based in Wotton itself, but this wasn't always the case. This ERF flatbed was operated by W. J. Jenkins Haulage Contractors, *above*, and the Heritage Centre displays an enamel advertising sign for White Lion Motorways, who also offered 'Modern Motor Coaches, Cars and Tractors' for hire. Note the two-digit phone numbers in both cases. (C. McC/JC)

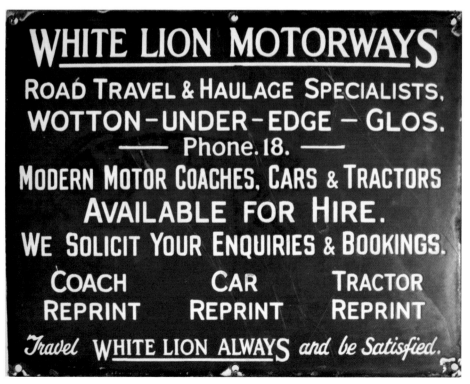

Around Wotton

Not only is Wotton located in an exceptionally beautiful part of the Cotswolds – the interesting crinkly bit on the edge rather than the more monotonous flatter land on the top – it is almost equidistant from the cities of Bristol, Bath and Gloucester, each around twenty miles away. Nearer to home, there are a number of small towns within a ten-mile radius including Dursley, Nailsworth, Berkeley and Thornbury. In the immediate vicinity, all within a good walking distance, there are several villages and hamlets. According to the official town guide of 1962–63, in Saxon times Wotton consisted of 'a group of six hamlets, Synwell, Wortley, Coombe, Bradley, Nibley and Huntingford'. Of these, Synwell, Coombe and Bradley have become subsumed within the town.

Wortley remains a separate hamlet just to the south. Its Chantry house includes parts of a chantry chapel from 1311, which was used by Kingswood's monks. Remains of a Roman villa have been found under one of the cottages. Up the hill from Wortley is Alderley with a number of fine houses, most notably Alderley Grange, which until recently was the Rose Hill School. Branching off from Alderley there is the road up to Tresham. Further south, two miles from Wotton, is Hillesley, a village of typical Cotswold stone buildings.

Wotton's biggest neighbour, Kingswood, is just down the hill past the Katharine Lady Berkeley School. Kingswood was once the site of a Cistercian Abbey, and it remained as a satellite of Wiltshire until 1844. Further west comes Charfield with its railway station, although nowadays it is more generally thought of as being on the route to the M5.

Wotton's most famous landmark is a cluster of trees planted on Wotton Hill, originally to mark Wellington's victory at Waterloo in 1815. Looking further along the escarpment to the north is the needle-like Tyndale Monument, erected above the village of North Nibley in 1866 to commemorate William Tyndale, who was burned at the stake for translating the New Testament into English. In the village is the seventeenth-century Nibley House, the former home of John Smyth, who was the steward of the Berkeley Estates. There are several other notable houses in the Wotton area including Newark Park in the Ozleworth Bottom valley. This was originally a Tudor hunting lodge until converted into a country house in 1790, and it is now owned by the National Trust. The other great buildings of note are the mills, which are mostly located on the Little Avon as it meanders through Kingswood and Huntingford down to the Severn Estuary.

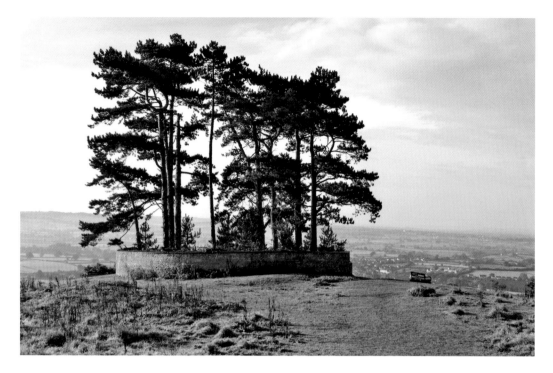

Wotton Hill

The town's most visible landmark is the cluster of trees perched on Wotton Hill. These replaced the earlier 'Waterloo' trees when the site was replanted and enclosed with a stone wall to commemorate Queen Victoria's Diamond Jubilee in 1887. Such was the town's strength of feeling for the old queen that they also commissioned a new town clock featuring her portrait – *see p. 35.* (JC)

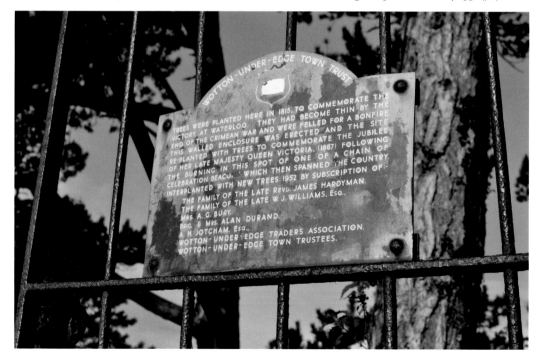

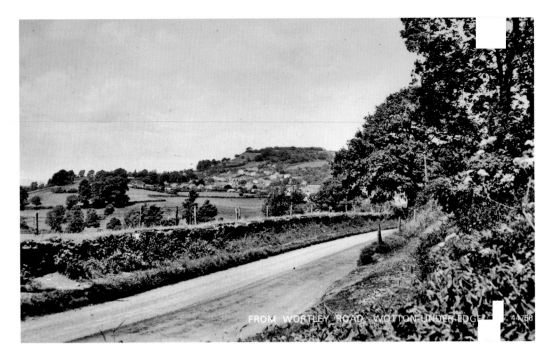

FROM WORTLEY ROAD. WOTTON-UNDER-EDGE 44756

Wortley Road

Heading southwards, the main road passes through Wortley, on to Alderley, Hillesley and then up the hill to Hawksbury Upton. This view looking back towards Wotton was taken from the Wortley Road at the top of Nind Lane. The roadside trees have grown considerably since the earlier photograph, and in the later image the new houses of the Bearlands estate can be seen in the middle distance. (JC)

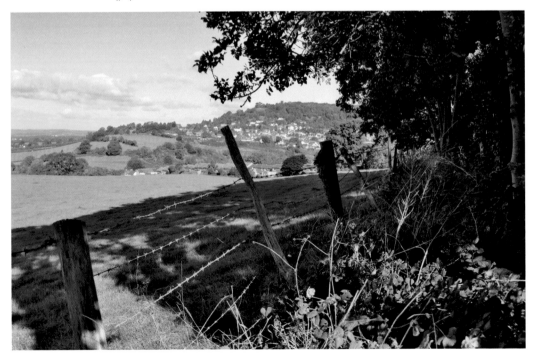

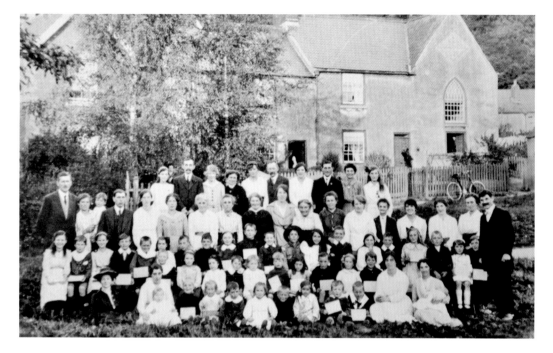

Synwell or Sinwell?

A hundred years ago, the Ordnance Survey maps show Sinwell as a settlement a little to the east of Wotton, separated from the town by open farmland. The photograph of the Sunday School, *above*, was taken in Edwardian times, before the Oliver Memorial Church was built alongside in the 1920s. It was Harry George Oliver who instigated the change in name from Sinwell to the old spelling, Synwell, no doubt because it didn't sit easily with his Christian sensitivities. (WHS/JC)

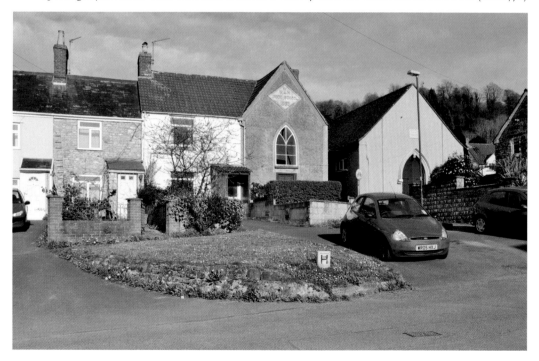

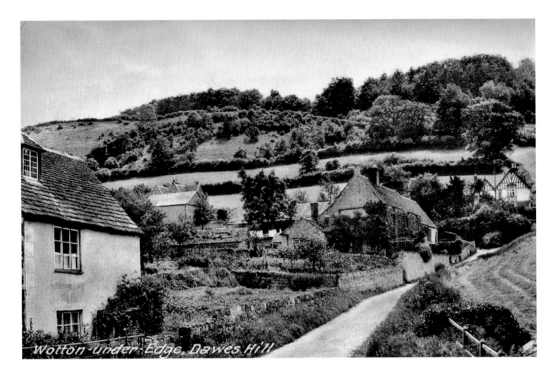

Dawes Hill, Coombe

Heading north-east from Synwell, Coombe Lane curves round and descends to the water pumping station via what used to be referred to as Dawes Hill, although this name doesn't seem to appear on any modern maps. Looking back up the lane, with the pumping station out of view to the left, the view has changed little, apart from the taller trees and some ugly electricity poles. (JC)

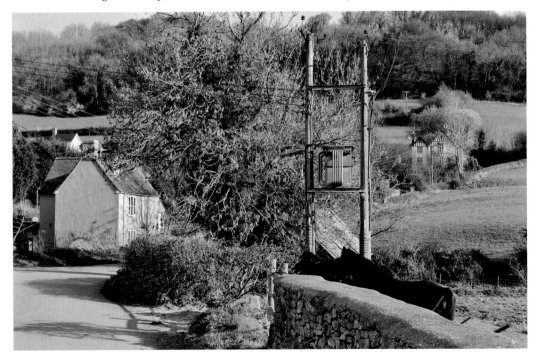

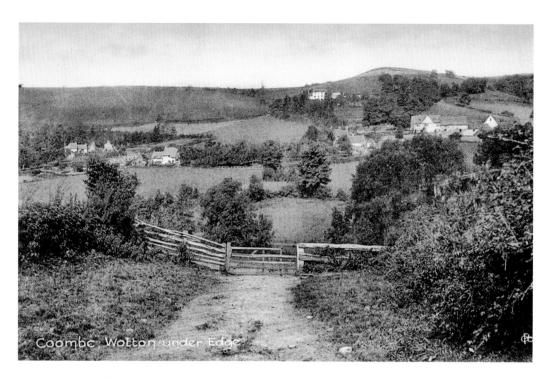

Coombe valley

The view from Blackquarries Hill, looking northwards across the Coombe valley to Coombe Hill. What looks like a lane in this old postcard is not even a farm track nowadays, although it is possible to make out the line of the old hedges. The B4058 out of Wotton – known locally as the 'W' – winds its way up the far side of the valley, before heading off past the golf club, towards Nailsworth. (JC)

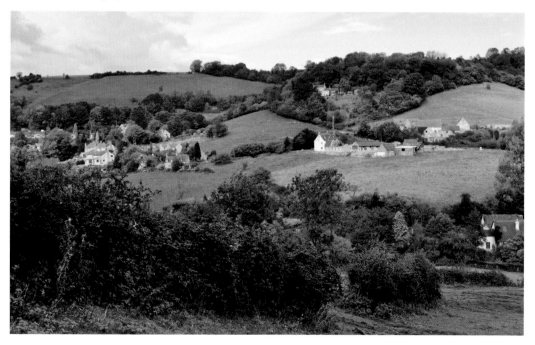

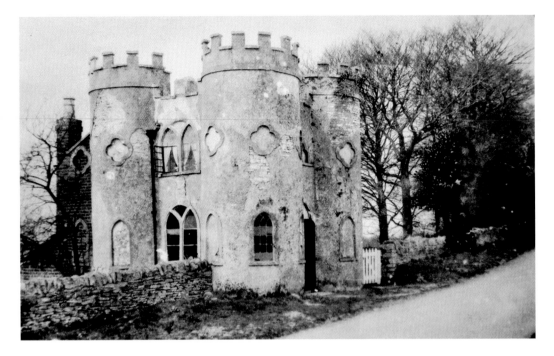

The Ridings Toll House

Wotton once had two toll houses near the town. This fine example with four crenelated towers stood opposite the Cotswold Edge golf club, a little up from the Ridings B&B at the top of the 'W'. By the 1900s, it was already falling into disrepair and was demolished in the 1920s for safety reasons. There is precious little evidence remaining that it ever existed, but careful inspection of the undergrowth reveals the foundation stones. (WHS/JC)

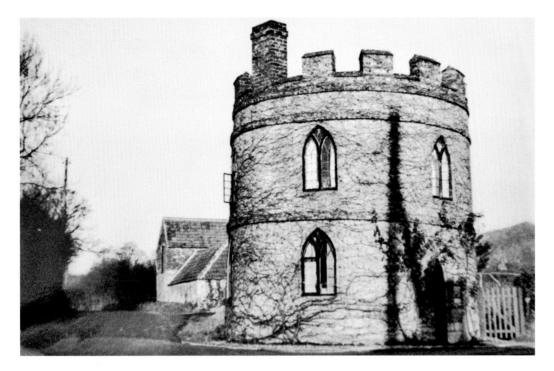

The Round House, Bushford Bridge

This former toll house still stands tall and proud, a familiar landmark on the road from Charfield to Wotton. It is located at Bushford Bridge, just along from New Mills, on the junction of the B4058 New Road and the road to Bradley Green. A private house now, in the summer it is smothered by green foliage. (WHS/JC)

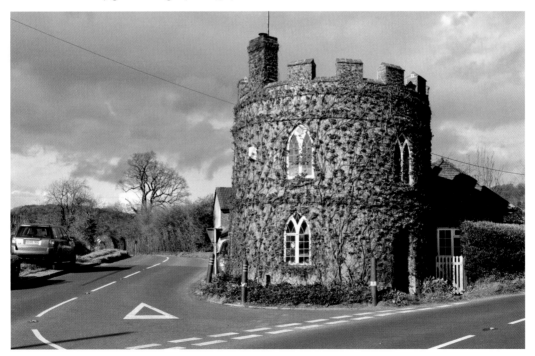

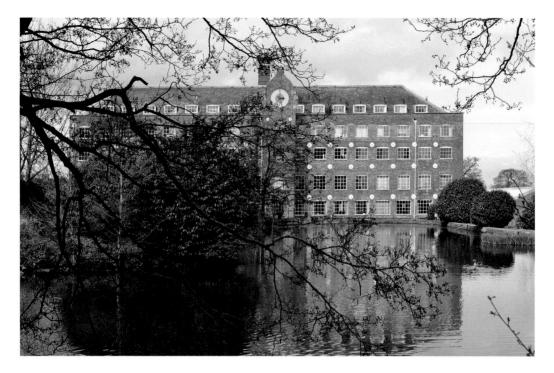

New Mills and Huntingford Mill

Originally known as Sury Mill, it was redeveloped to create this fine example of an early-nineteenth-century woollen mill. New Mill is arranged on a north–south axis and has six storeys in red brick with central clock tower. Today, it is the headquarters for Renishaw plc, a company that produces specialised measuring equipment. Huntingford Mill, *below*, is far smaller and has had a mixed career as a cloth mill, a corn mill, and a hotel/restaurant. (JC)

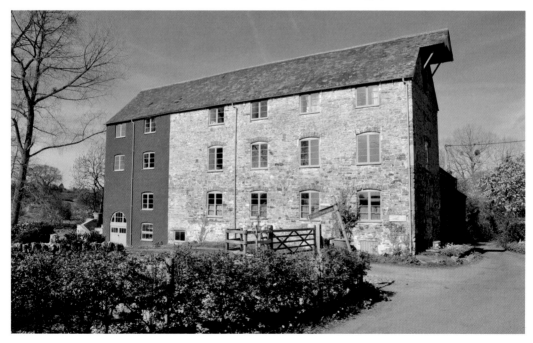

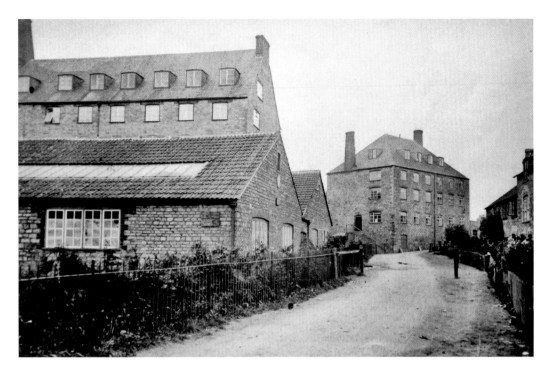

Charfield Mills

This consists of a group of three mill buildings, plus associated houses and workers' cottages. The largest of the mills, shown to the left, was built in 1829. Powered by two waterwheels and four storeys high, this imposing building became known locally as the Pin Mill after the pin-making company Perkins & Mamont occupied it. The other mill building, to the right, is Bone Mill. Today, the mill complex is home to a number of businesses. (WHS/JC)

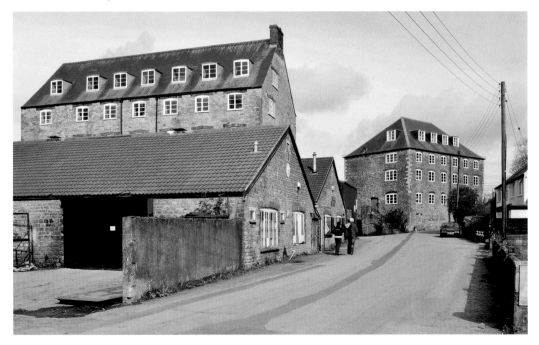

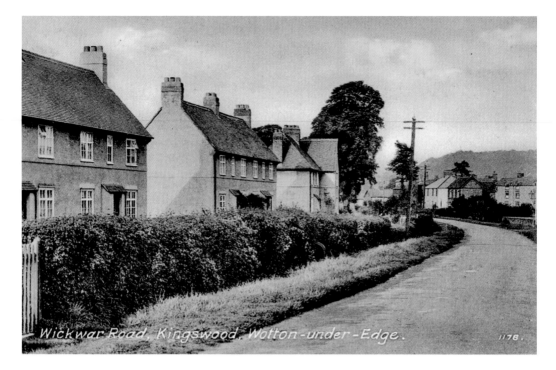

Wickwar Road, Kingswood, Wotton-under-Edge. 1178.

Kingswood

The village of Kingswood is located only one mile to the south-west of Wotton, although until the Counties Act of 1844, it was actually a detached offshoot of Wiltshire. The Wickwar Road, the B4060, passes through the edge of Kingswood and this view looks northwards into the village. At first, it is hard to reconcile the two photographs, but the roofs have lost most of their chimneys and the gaps between the houses have been filled with later extensions. (WHS/JC)

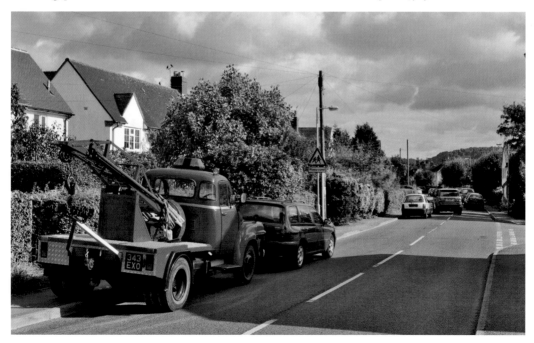

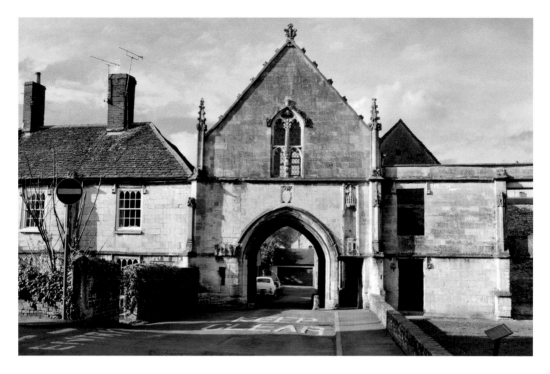

Kingswood Abbey

The Cistercian Abbey at Kingswood was founded in 1169 by William of Berkeley. All that remains is this late-sixteenth-century gatehouse, although various bits of the abbey were reused in other buildings in the area. In this old postcard, *shown below*, the structure to the right of the gateway was still habitable. (JC/WHS)

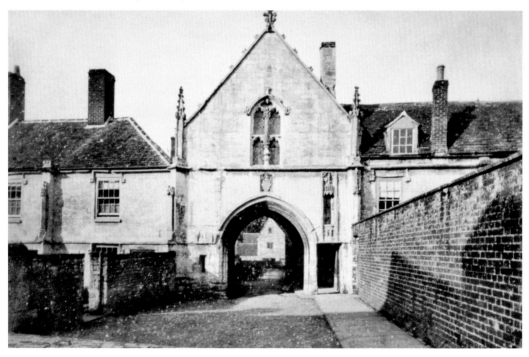

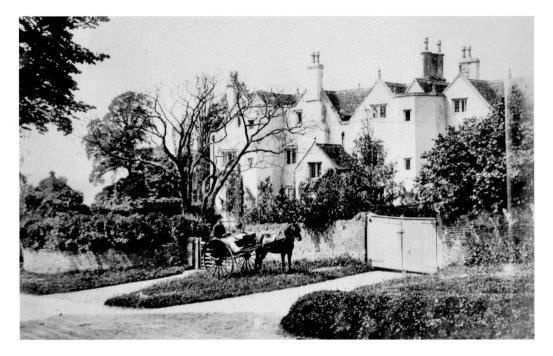

Bradley Court

This Elizabethan mansion was built in 1568 by one of the last Berkeley owners, and is located on the edge of the Berkeley Vale just to the north-west of Wotton, on the main route to Berkeley. Overlooking Bradley Green, the house remains a private residence and is not open to the public. A tall hedge ensures privacy, but does not hide the harsh paintwork on the south-facing façade. (WHS/JC)

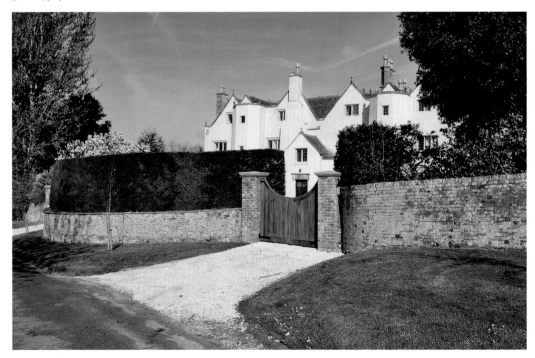

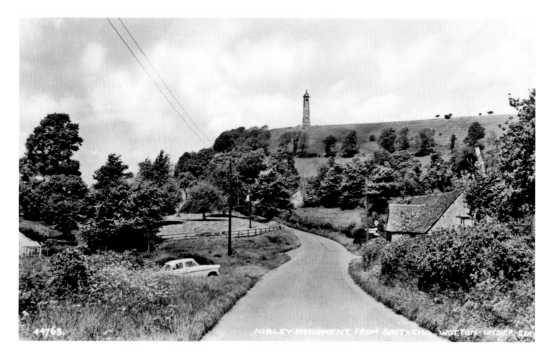

Southend and the Tyndale Monument

The Nibley Tower, as it is more commonly known, was built in 1866 to commemorate the life of William Tyndale, who was burnt at the stake in 1536. His sin had been to translate the Bible into English for a wider readership beyond the Church hierarchy. The 111 foot tower stands above the village of North Nibley, where Tyndale is reputed to have been born. These views are from Southend, a small hamlet on the main road to Wotton. (JC)

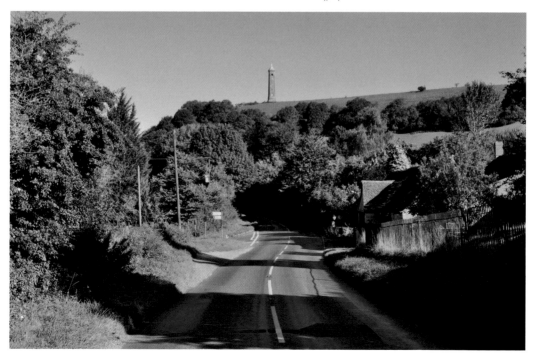

Acknowledgements

I would like to thank the chairman of the Wotton-under-Edge Historical Society (WHS), David Baird, for providing access to their extensive collection of photographs of the town, and the society's members at the Heritage Centre for their kind assistance. I am also grateful to the many people of Wotton who have variously allowed me to photograph them or to clamber through their property. Thanks to Campbell McCutcheon (C. McC) at Amberley Publishing, the US Library of Congress (LoC) and R. H. Thomas & Son for additional images, and to my wife Ute for proofreading and patience. Unless otherwise credited, all new photography is by the author (JC).

The Wotton-under-Edge Historical Society aims to protect, preserve and promote the history and heritage of Wotton and the surrounding area for the interest, education and enjoyment of both local residents and visitors. The Society holds meetings, produces publications and encourages research. It also maintains a reference library and archive, and runs the Wotton-under-Edge Heritage Centre, which houses the Society's collection of artifacts of local interest.

You can help support the work of the Heritage Centre by becoming a member of the Historical Society. Members receive a copy of the annual publication and are entitled to attend historical meetings, arranged by the Society, on a wide range of fascinating topics. In addition, members have free access to the Historical Society archive, which contains resources for family and local historians as well as local history researchers.

To become a member, call in at the Wotton-under-Edge Heritage Centre, which is situated on The Chipping, or download an application form from www.wottonheritage.com